OPULENCE AND DEVOTION
Brazilian Baroque Art

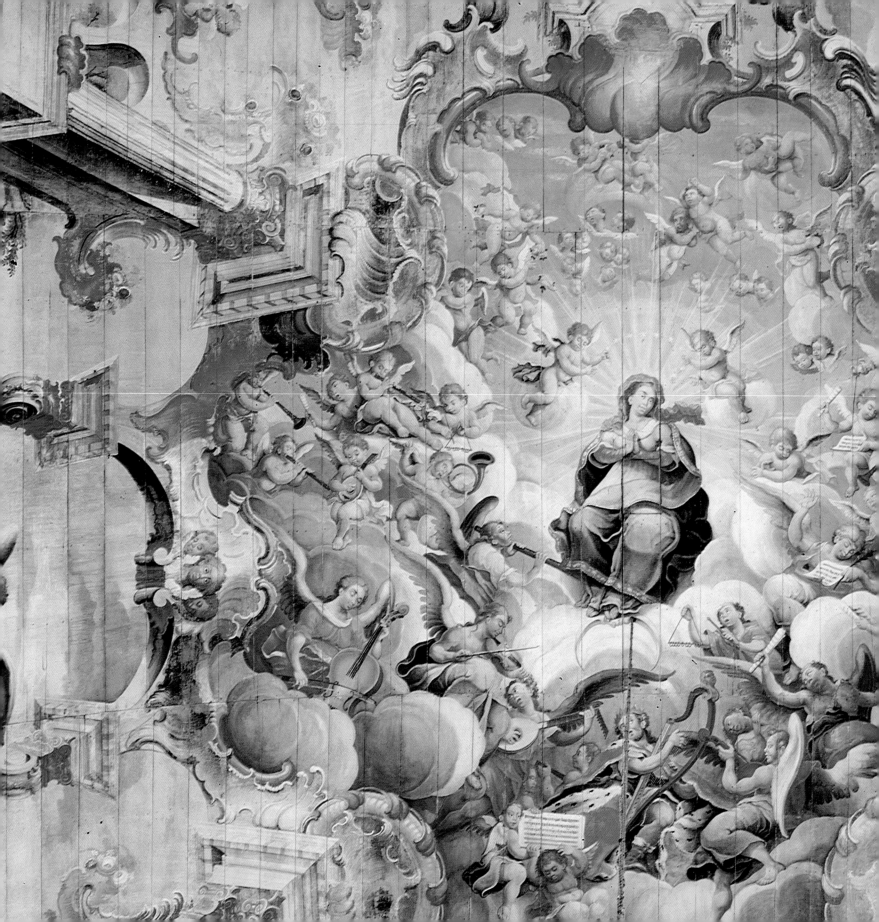

OPULENCE AND DEVOTION
Brazilian Baroque Art

Catherine Whistler

with essays by
Cristina Ávila and A.J.R. Russell-Wood

BrasilConnects / Ashmolean Museum

Opulence and Devotion: Brazilian Baroque Art

Ashmolean Museum, Oxford
25 October 2001 to 3 February 2002
produced in collaboration with
BrasilConnects

BrasilConnects

Chairman
Edemar Cid Ferreira

Vice Chairman
Pedro Paulo de Sena Madureira

Directors
Beatriz Pimenta Camargo
Julio Landmann
René Parrini

Chief Curator
Nelson Aguilar

International Relations
Helena Gasparian

Project Executive Director
Emilio Kalil

Environment Executive Director
José Pascowitch

Marketing and Communication
Executive Director
Júlio Cesar Bin

Business Development Executive
Director
Marco F. Simões

Finance and Administration
Executive Director
Raul Félix

**BrasilConnects Exhibition Team,
Brazil**

Project Director
Emilio Kalil

Associate Chief Curator
Franklin Espath Pedroso

Assistants
Robson Outeiro
Silvana Marani Lopes

Curator
Mari Marino

Coordinator
Elisio Yamada

Assistant
Ana Paula Ruzzante

Production Coordinator
Miriam Bolsoni

Transportation
Fernanda Engler, Ivo Tessitore and
Patricia Lima

Exhibition Team, UK

Project Manager
Tassy Barham

Coordinator
Cristiana Mazzucchelli

Catalogue Team

Project Assistant
Flora Carnwath

Catalogue Design
Tim Harvey

Catalogue Production
Ian Charlton (Ashmolean Museum)

BrasilConnects
Parque Ibirapuera Portão 10
Pavilhão da Pinacoteca
São Paulo – SP – Brazil
04094-050
Phone: +55.11.5573.6073
www.brasilconnects.org

Ashmolean Museum
University of Oxford
Beaumont Street
Oxford OX1 2PH
Phone: 01865 278000
www.ashmol.ox.ac.uk

Exhibition curated by Mari Marino
and Catherine Whistler

British Library Cataloguing in
Publication Data

A catalogue record for this book is
available from the British Library

ISBN 1 85444 157 4

Printed by Snoeck-Ducaju & Zoon,
Gent

Photographic acknowledgements

Denise Andrade
Marcos Campos
Romulo Fialdini
Adelmo Lapa
Breno Laprovitera
Juninho Motta
José Ronaldo
Fernando Zago

frontispiece: Manoel da Costa Ataíde
(1762–1830): detail of the painted
ceiling, São Francisco de Assis, Ouro
Preto

cover: **Saint Elesbaan Victorious**
(cat. 61)

Contents

Lenders to the Exhibition 6

Preface 7
Edemar Cid Ferreira

Foreword 8
Christopher Brown

A Chronology of Important Dates in Brazilian History 13

Patronage and Expressions of the Baroque in Colonial Brazil 17
A.J.R. Russell-Wood

Baroque Art in Brazil: the Success of Cultural Transplantation 37
Cristina Ávila

Art and Devotion in Seventeenth- and Eighteenth-Century Brazil 47
Catherine Whistler

Checklist of Works of Art in the Exhibition 86

Named Sculptors Represented in the Exhibition 91

Some Popular Brazilian Cults of Saints Represented in the Exhibition 92

Further Reading: Some Sources in English 95

Lenders to the Exhibition

Acervo Artístico Cultural dos Palácios do Governo do Estado de São Paulo
Acervo MINC – 5a Superintendência Regional, IPHAN, Pernambuco
Arquidiocese de Mariana – Igreja do Rosário dos Pretos de Mariana, Minas Gerais
Confraria de Nossa Senhora do Rosário dos Homens Pretos de Olinda, Olinda, Pernambuco
Fundação Pierre Chalita, Maceló, Alagoas
Igreja do Nossa Senhora do Pilar, Ouro Preto
Igreja do Mosteiro de São Bento, Olinda, Pernambuco
Museu Arquidiocesano de Arte Sacra, Mariana, Minas Gerais
Museu de Arte Sacra da Arquidiocese de Curitiba, Paraná
Museu de Arte Sacra de Santos, São Paulo
Museu do Estado de Pernambuco, FUNDARPE – Secretaria de Cultura, Recife
Museu do Oratório Coleção Angela Gutierrez, Ouro Preto
Museu Júlio de Castilhos, Porte Alegre, Rio Grande do Sul
Museu Vicente Pallotti, Santa Maria, Rio Grande do Sul

João Maurício de Araújo Pinho, Rio de Janeiro
Ladi Biezus, São Paulo
Beatriz and Mário Pimenta Camargo Collection, São Paulo
Mr and Mrs José Maria Carvalho, Rio de Janeiro
Antonio Carlos Curiati, São Paulo
Domingos Giobbi, São Paulo
Angela Gutierrez, Belo Horizonte
James Li, São Paulo
João Marino Collection, São Paulo
Orandi Momesso, São Paulo
Max Perlingeiro, Rio de Janeiro
Roberto Zarzur, São Paulo

Preface

BrasilConnects is delighted to present the essence of Brazilian art, revealed in its most privileged expression in the Baroque.

In Brazil, this style became a sort of birth certificate of the new nation. More than that, in Brazil Amerindian and African contributions flowed into the European sources. Thus there took place a transcultural phenomenon that could no longer be appraised in the light of metropolitan Portuguese art. Some of the best historians, among them Mário de Andrade, Germain Bazin, John Bury and Robert C. Smith, recognized this fact, about which they produced inspiring studies.

In the exhibition at the Ashmolean Museum seventeenth- and eighteenth-century images used for public and private worship are displayed. Some of them are anonymous, others are known to be by the greatest artists of the Colonial Era, such as Frei Agostinho de Jesus, Francisco Xavier de Brito and, last but not least, Antônio Francisco Lisboa, known as Aleijadinho. Silver pieces complement the collection.

We hope that this exhibition becomes an invitation for a British audience to learn more about the architectural, musical, literary and artistic contexts that Baroque culture engendered in Brazil. A pilgrimage to Salvador, Recife, Ouro Preto and to one of the largest artistic complexes in America, the church of Bom Jesus de Matosinhos in Congonhas do Campo, with its atrium and the Stations of the Cross, led André Malraux to consider Aleijadinho the greatest artist of Christendom in the 18th century.

To present an exhibition in a city that harbours one the world's great centres of knowledge redefines the meaning of the pieces that are part of it. Now it is a matter of propitiating, from a prestigious collection with worldwide recognition, a serene, correct appraisal of a world in the making.

Edemar Cid Ferreira

Foreword

It is with great pleasure that the Ashmolean presents, for the first time in Britain, an exhibition of Brazilian sculpture, private altarpieces and silver from the seventeenth and eighteenth centuries. The works of art on display are all of religious subjects and had devotional and celebratory aims; they belong to an essentially Baroque culture in which the appeal of religious art to the senses and to the imagination was paramount, one that delighted in the opulent and the spectacular. This exhibition does not present a survey of Brazilian art of the period, an impossible task given the huge variety of work produced in areas as different from each other as missionary villages, grand estates, mining towns or thriving ports, as well as the complex interaction of Portuguese artists and imported artefacts with Brazilian-born artisans and sculptors. Instead the displays will provide insights into some of the key areas of production for both private and public purposes – especially the southern regions in the seventeenth century and Minas Gerais and Pernambuco in the eighteenth – and will highlight the work of the most important artist of the period, Antônio Francisco Lisboa, known as Aleijadinho.

The aim of the catalogue is to present a context for the works of art in the exhibition. A historical overview is provided in a detailed chronology of important events in the history of Brazil as a colony of Portugal. Professor A.J.R. Russell-Wood's essay describes the social and economic conditions that created a climate in which patronage of the arts could flourish, and the nature of the arts of the Baroque in Brazil. Dr Cristina Ávila provides an art-historical survey of the Baroque period, outlining the main developments and the key figures in architecture, sculpture and painting. Dr Catherine Whistler examines the religious context for the works of art in the exhibition and the ways in which they would have been viewed and perceived at the time. It is our hope that the catalogue and the educational and academic events associated with the exhibition will encourage the growth of interest in this country in the fascinating and beautiful art of the Baroque in Brazil.

Opulence and Devotion: Brazilian Baroque Art follows our successful summer exhibition of the work of Ana Maria Pacheco, one of the most exciting of contemporary Brazilian artists. These and other initiatives mark a new phase in the history of the Ashmolean, where I intend that every effort should be made to reach out to a wider audience than ever before. This exhibition came about thanks to the proposal of Edemar Cid Ferreira that the Ashmolean should be associated with the series of international exhibitions sponsored by his organization, BrasilConnects, and supported by His Excellency Mr Sergio Silva do Amaral, Brazilian ambassador to the United Kingdom. I should like to pay tribute to Mr Cid Ferreira for his generous sponsorship, and to Professor Nelson Aguilar, Dr Fausto Godoy, Mr Emilio Kalil and Mrs Mary de Vasconcellos Marino for making the exhibition possible; warm thanks must also go to Miss Tassy Barham and Mr Elisio Yamada for their hard work. My sincere gratitude must also be expressed to the various Brazilian lenders to the exhibition, who have agreed to give their further support to one of the international projects of BrasilConnects.

In Britain, the institutions participating in the BrasilConnects series of exhibitions are the British Museum (*Unknown Amazon: Nature and Culture in Ancient Brazil*); the Fitzwilliam Museum, Cambridge (*Heroes and Artists: Brazilian Popular Art*); the Museum of Modern Art, Oxford (*Experiment Experiência: Art in Brazil 1968–2000*), and the Pitt Rivers Museum, Oxford (*Acts of Faith: Brazilian Contemporary Photography*). The Pitt Rivers exhibition, hosted by the Ashmolean, is an exploration of popular religion which will complement *Opulence and Devotion* perfectly, and my thanks go to the curator, Dr Elizabeth Edwards, for her support and collaboration. The energy and expertise of Professor Leslie Bethell, Director of the Centre for Brazilian Studies in Oxford, has been crucial for the success of the three Oxford exhibitions, and I am grateful to him and his staff for their assistance. The curator of *Opulence and Devotion*, Dr Catherine Whistler, would like to thank Professor A.J.R. Russell-Wood and Dr Cristina Ávila for generously agreeing to contribute essays to the catalogue, and Mr J.B. Bury, Dr Angela Delaforce, Mrs Angela Gutierrez and Professor Myriam A. Ribeiro de Oliveira for their advice and encouragement.

Finally, I should like to acknowledge the efficiency and commitment of the members of staff of the Ashmolean who were closely involved in this project: Daniel Bone, Sarah Brown, Graeme Campbell, Flora Carnwath, Ian Charlton, Geraldine Glynn, Roger Hobby, Alan Kitchen, Emmajane Lawrence, Dec McCarthy, Mark Norman and Julie Summers.

Dr Christopher Brown
Director
Ashmolean Museum

overleaf: São Bento, Rio de Janeiro

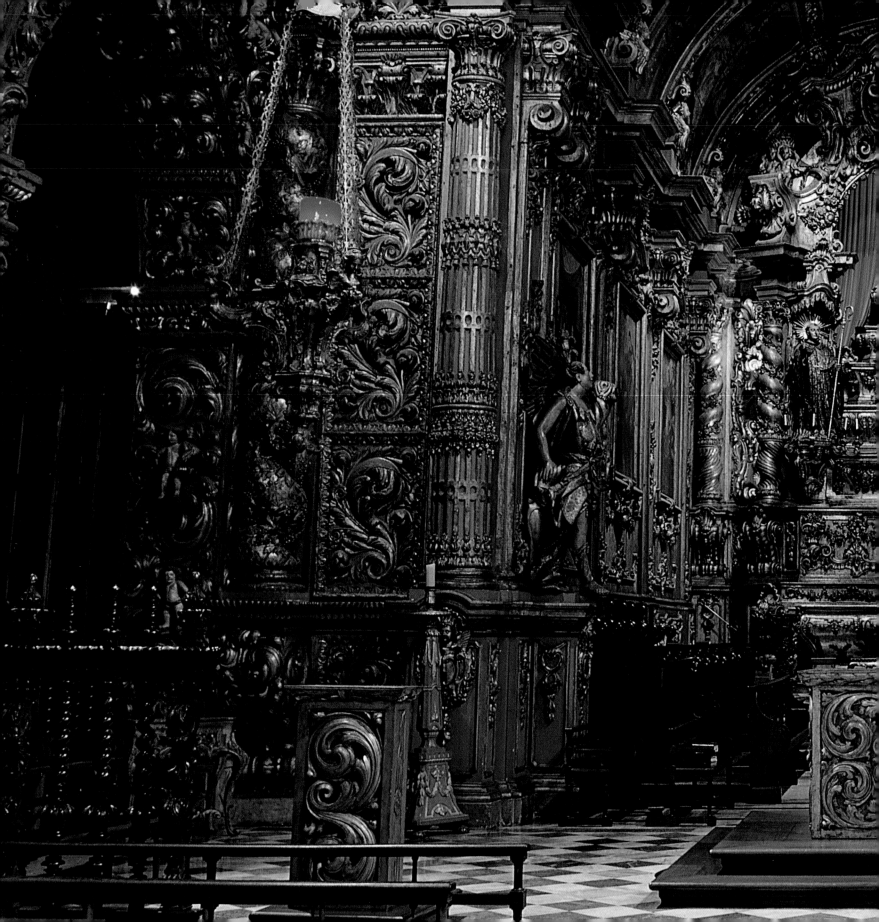

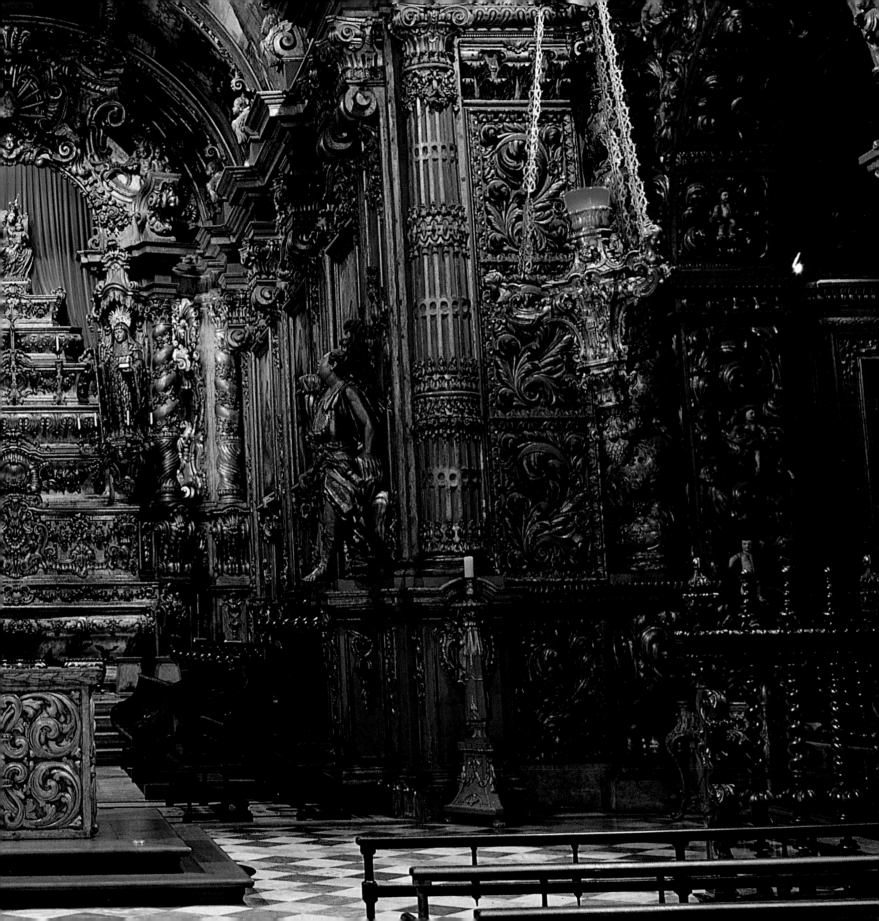

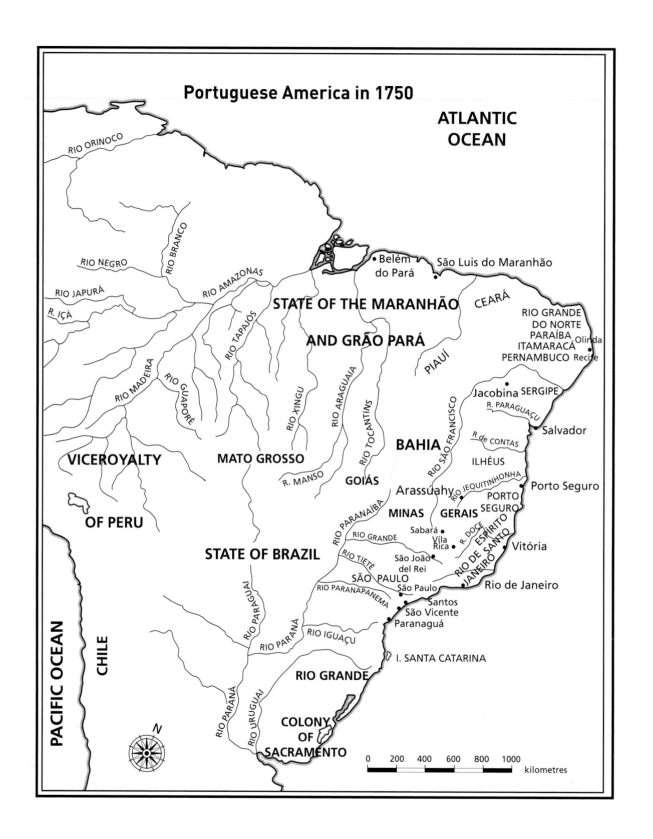

Portuguese America in 1750

ATLANTIC OCEAN

RIO ORINOCO

RIO BRANCO

RIO NEGRO

RIO JAPURÁ

R. IÇÁ

RIO AMAZONAS

Belém do Pará

São Luis do Maranhão

STATE OF THE MARANHÃO

CEARÁ

AND GRÃO PARÁ

RIO TAPAJÓS

RIO MADEIRA

RIO GUAPORÉ

RIO XINGU

RIO ARAGUAIA

RIO TOCANTINS

PIAUÍ

RIO GRANDE DO NORTE

PARAÍBA

ITAMARACÁ

PERNAMBUCO

Olinda

Recife

Jacobina

SERGIPE

R. PARAGUAÇU

RIO SÃO FRANCISCO

Salvador

VICEROYALTY

MATO GROSSO

R. MANSO

GOIÁS

R de CONTAS

BAHIA

ILHÉUS

OF PERU

Arassúahy

RIO JEQUITINHONHA

PORTO SEGURO

Porto Seguro

RIO PARANAÍBA

MINAS

GERAIS

PORTO SEGURO

RIO GRANDE

Sabará

Víla Rica

R. DOCE

ESPIRITO SANTO

Vitória

STATE OF BRAZIL

RIO TIETÊ

São João del Rei

RIO DE JANEIRO

SÃO PAULO

São Paulo

Rio de Janeiro

RIO PARANAPANEMA

Santos

São Vicente

Paranaguá

PACIFIC OCEAN

CHILE

RIO PARAGUAI

RIO PARANÁ

RIO IGUAÇU

I. SANTA CATARINA

RIO GRANDE

N

RIO PARANÁ

RIO URUGUAI

COLONY OF SACRAMENTO

0 200 400 600 800 1000

kilometres

A Chronology of Important Dates in Brazilian History

1494 The Treaty of Tordesillas divides the New World between Spain and Portugal.

1500 Pedro Alvares Cabral, on a voyage to India, discovers Brazil and claims the land for Portugal.

1530 Expedition of Martim Afonso de Sousa to colonize.

1534–6 A system of hereditary captaincies is established in Brazil to encourage exploration and colonisation; the country is divided among twelve lord-proprietors (*donatários*).

1537 Pope Paul III prohibits the enslavement of Indians, including those of Brazil.

1538 The first known shipment of slaves arrives from Africa.

1549 Centralised government is set up under Tomé de Sousa in Bahia. The city of Salvador da Bahia is founded. The first Jesuits arrive in Brazil, headed by Manoel de Nóbrega.

1551 Portuguese America's first bishopric is established at Bahia.

1554 Father Manoel de Nóbrega establishes a Jesuit school at Piratininga, on the present site of the city of São Paulo.

1555 Nicholas Durand de Villegagnon establishes a French colony, France Antarctique, on Guanabara Bay.

1565 Foundation of Rio de Janeiro.

1567 French colonists are expelled from the region around Rio de Janeiro.

1580 The Spanish Hapsburgs establish control over the Portuguese kingdom and indirectly over Brazil and other Portuguese colonies. Philip II of Spain becomes Philip I of Portugal.

1591–5 First visit of the Inquisition to Brazil, dealing with Bahia and Pernambuco.

1595 Philip II of Spain (I of Portugal) bans the enslavement of Brazilian Indians.

1612 The French establish a colony at São Luís do Maranhão.

1615 The Portuguese seize Maranhão from the French, broadening their control over northern Brazil.

1621 The State of Maranhão is created and includes Maranhão, Pará and Ceará. It is given its own governor and separated from the jurisdiction of the governor-general in Bahia.

1624 The Dutch capture Bahia.

1625 A combined Spanish-Portuguese fleet drives the Dutch out of Bahia.

1630 The Dutch seize Recife and Olinda. This signals the beginning of a period of Dutch conquest and colonisation of Pernambuco and other parts of northern Brazil.

1637 Johan Maurits of Nassau becomes governor of Dutch Brazil.

1640 Portugal declares its independence from Spain.

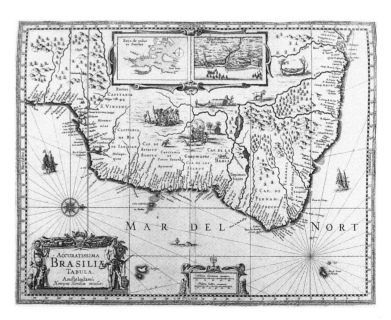

Henrick Hondius (1597–1651), **Map of Brazil with inset views of the Bay of All Saints, Salvador, and the city of Olinda in Pernambuco.** Engraving, probably 1630s, Sutherland Collection, Ashmolean Museum

Johan Maurits, Count of Nassau-Siegen (1604–79). Engraving, Hope Collection, Ashmolean Museum

IOHANNES MAVRITI, S.R.I. PRINCEPS NASOV. etc. etc. Sereniſs. Elect. Brandeb. ad Comitia Elect. Francof. Plenipotentiarius Principalis.

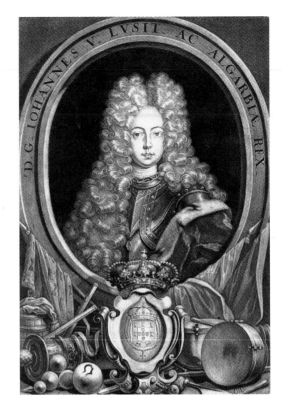

Christoph Weigel (1654–1725) **João V of Portugal (1689–1751).** Mezzotint, probably dating from soon after the King's accession in 1706 Hope Collection, Ashmolean Museum

Philip IV (III of Portugal) is overthrown and the Duke of Bragança is proclaimed João IV of Portugal.

1643	Johan Maurits of Nassau's town of Mauricia (Recife) is completed.
1644	Johan Maurits of Nassau returns to Europe.
1648	The Portuguese colonise Paraná and further expansion to the South begins.
1654	Treaty of Taborda. The Dutch surrender Recife and withdraw from Brazil after a long armed struggle.
1676	Bahia is raised to the status of an archdiocese. Two new dioceses are created: Olinda and Rio de Janeiro, the latter including all of southern Brazil.
1677	Diocese of Maranhão established.
1695	Paulistas discover gold in Minas Gerais, beginning a gold rush and an era of colonisation and development in the region.
1708–9	War of the *Emboabas* (outsiders) as the Paulistas fight with new prospectors.
1709	Captaincy of São Paulo and Minas Gerais is established (to be separated into 2 captaincies in 1720).
1710	Recife is raised to the status of a town (*vila*). War of the Mascates breaks out between Olinda and Recife.
1722	Gold is discovered in Goiás and Mato Grosso.
1729	Large diamond deposits are discovered at Tejuco (the modern Diamantina) in Minas Gerais.
1750	The Treaty of Madrid between Spain and Portugal recognizes de facto Portuguese control over regions south and west of the line set by the 1494 Treaty of Tordesillas.
1751	João V dies and is succeeded by José I. Sebastião José de Carvalho e Melo (the future Marquis of Pombal) becomes chief minister of the Portuguese monarch.
1759	Pombal expels the Jesuits from Portugal and Brazil.
1763	The capital is transferred from Salvador da Bahia to Rio de Janeiro. Brazil is raised to the status of a vice-royalty.

1777	The Treaty of San Ildefonso between Spain and Brazil establishes Brazil's western and southern boundaries, consolidating the country in roughly its present form. Death of José I and the disgrace of the Marquis of Pombal. Maria I becomes queen of Portugal.
1789	The *Inconfidência Mineira*, a revolutionary conspiracy aiming to establish a republic, is exposed in Minas Gerais.
1798	'Revolt of the Tailors', a revolutionary conspiracy involving free mulattos and slaves, is uncovered in Salvador da Bahia.
1807–8	The Portuguese Royal court is transferred to Rio de Janeiro under British naval escort.
1808	The first printing press is established; the first newspapers are published in Rio de Janeiro. Brazilian ports are opened to world trade.
1815	Brazil is proclaimed a kingdom equal in status to Portugal and the Algarve.

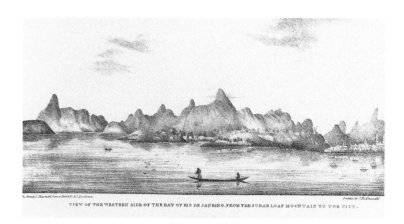

View of the Western Side of the Bay of Rio de Janeiro, from the Sugar Loaf Mountain to the City. Lithograph, drawn on the stone by C. Shoosmith, from a sketch by J. Henderson, and printed by C. Hullmandel. First published in James Henderson *A History of the Brazil*, London 1821. Hope Collection, Ashmolean Museum

1816	With the death of Queen Maria I, Dom João is crowned King João VI of Portugal, Brazil and the Algarve.
1821	King João VI returns to Lisbon, leaving his son, Dom Pedro, behind in Brazil as regent.
1822	Prince Pedro declares Brazil's independence from Portugal and receives the title of emperor.
1850	The Brazilian General Assembly passes the Queirós Law, abolishing the African slave trade to Brazil and specifying means of enforcing the law and punishing its violators.
1851	The African slave trade virtually ends, but is quickly replaced by an inter-provincial slave trade.
1888	The Golden Law abolishes the slave trade without compensation for slaveholders.
1889	The emperor is deposed by the army and a republic is established.

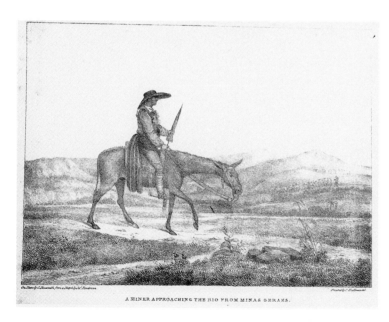

A Miner Approaching the Rio from Minas Geraes. Lithograph, drawn on the stone by C. Shoosmith, from a sketch by J. Henderson, and printed by C. Hullmandel. First published in James Henderson *A History of the Brazil*, London 1821. Hope Collection, Ashmolean Museum

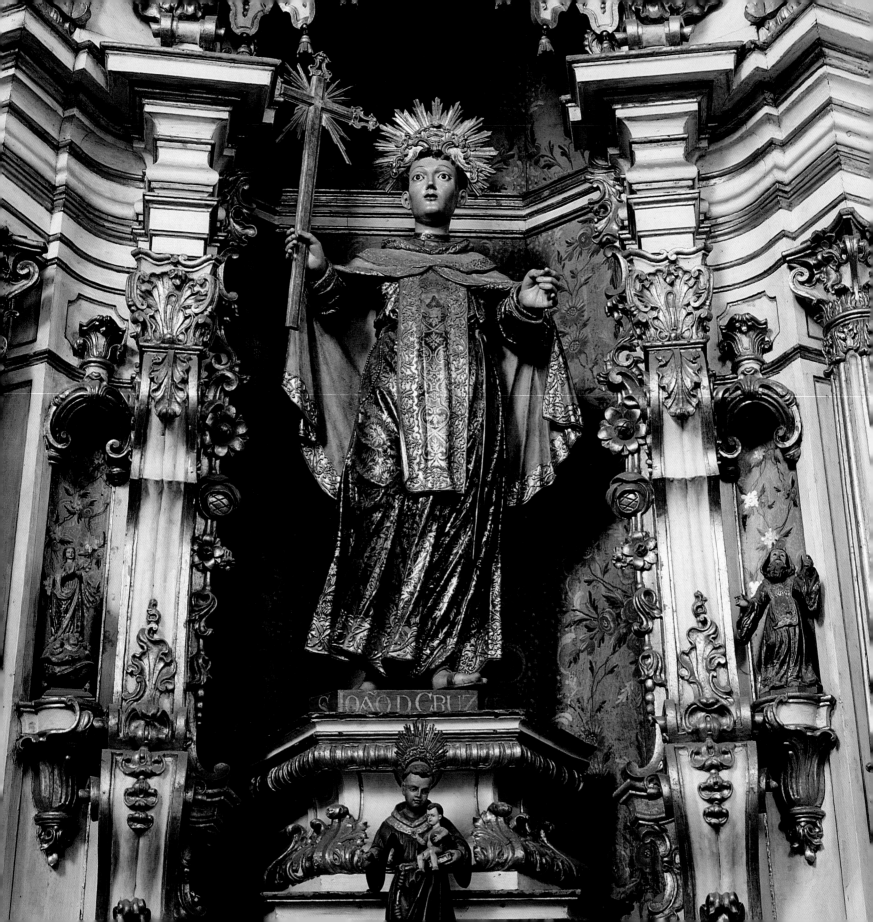

S. IOÃO D CRUZ

Patronage and Expressions of the Baroque in Colonial Brazil

In Brazil the term Baroque embraces a period from the late seventeenth century to about 1760. The term is applicable not solely to art, architecture, literature, theatre and music but to a lifestyle and a mentality which reflected the strength of post-Tridentine Catholicism and the prolongation of the Counter-Reformation into the eighteenth century. In Brazil the Baroque found expression primarily in religious architecture, painting and sculpture, in literature and music, in language, and in public celebrations. It was characterised by excess, erudition, complexity and convolution, richness of detail, exuberance, exaggeration and hyperbole, solemnity and ritual, ceremony and pageantry, and contrast. It was an escape from the regimentation and bounds of classicism. Expressions of the Baroque were linked to different stages in the evolution of what became Portugal's richest colony, in a seaborne empire which, in its heyday, extended from Brazil to the Bandas.

While there are examples of the Baroque in many parts of colonial Brazil, the geography of the Baroque is associated primarily with two very different regions. There is the littoral from Belém do Pará to Santos, with navigable rivers, deep water bays, tidal inlets and fertile lands. The coastal regions of the northeast have wet and dry seasons, small fluctuations in temperature, and rich soil conducive to cultivation of sugar cane and agriculture. In the interior is the semi-arid *sertão* suitable for cattle raising. By way of contrast, the south-central highlands of the interior have mountains, deep valleys, fast flowing rivers and, in the seventeenth and eighteenth centuries, dense forests. The weather is unpredictable: brilliant sunshine, lightning, thunderstorms, and torrential rains, 'four seasons in a single day', in the local saying. There the rivers and mountains contained gold and diamonds, whence the name Minas Gerais (General Mines). Northwest from Minas Gerais, on the plateau of the central west, where there was dense forest (*mato grosso*), alluvial gold was also found in the eighteenth century in what are now the states of Goiás and Mato Grosso.

Agriculture was the mainstay of the Brazilian colonial economy. The Portuguese crown looked to Brazil to provide raw materials to enrich the mother country. Sugar was preeminent and the most consistent generator of revenue throughout the colonial period. Pernambuco and Bahia made Brazil dominant in the European sugar market from the late 1560s to 1670. This prosperity awoke the cupidity of the Dutch West India Company whose personnel occupied Salvador (1624–25) and substantial parts of the northeast (1630–54) with destruction of plantations and sugar mills, and disruption of the industry. Rising slave costs and falling sugar prices resulted in a downturn in the sugar economy and agricultural sector, leading to mixed fortunes in the first half of the eighteenth century, with agricultural recovery in the coastal regions only beginning in the 1760s.[1] Other sectors of the eighteenth-century economy were open-range livestock raising, agricultural products (cacao, rice, cotton and indigo), tobacco, timber, commercial farming, and subsistence mixed farming. Sugar production greatly increased in the eighteenth century in the captaincies of Rio de Janeiro and São Paulo but only in the northeast did a plantation society come into being. The 'golden age' of Brazil was short-lived. Discovery of gold in paying quantities in rivers of the district of Rio das Velhas in the mid 1690s spurred gold rushes over the next forty years in Minas Gerais, southern Bahia, Cuiabá, Goiás and Guaporé. Alluvial panning predominated, but there was limited gallery mining. Already in the 1730s there were indications that in some parts of Minas Gerais, gold production was on the wane. After 1749 overall production suddenly declined. Goiás and Mato Grosso picked up some of the slack in the 1750s but by the 1770s gold production in Brazil was in the doldrums. Diamond production was a crown monopoly, but this industry too collapsed in the 1770s. Despite mixed fortunes, sugar in the northeast, gold in Minas Gerais, and commerce in port cities such as Rio de Janeiro and Salvador and in São Paulo and towns of the interior, created economic and social milieux

Antônio Francisco Lisboa, known as Aleijadinho (1738–1814)

Saint John of the Cross, Nossa Senhora do Carmo, Sabará

conducive to expressions of the Baroque in Brazil.

The Baroque in Brazil is associated with urban centres. Towns (*vilas*) were slow to develop. A handful (São Vicente, Olinda, Recife, and Santos) preceded the establishment of crown government in 1549 and construction of the capital city of Salvador. The sixteenth and seventeenth centuries saw port towns and cities established along the coast. These were bunched in clusters: the north (Belém, São Luis do Maranhão), northeast (Olinda, Recife, Salvador), south-east (Rio de Janeiro, Santos, São Vicente). An exception was São Paulo (founded 1554 by Jesuits) on the Piratininga plateau. The later seventeenth century saw creation of townships away from the coast. Only with gold rushes to Minas Gerais initially and subsequently further west, resulting in major demographic reorientation, did towns come into being in the interior. There was a transition from anarchic mining encampments to stable municipal governance. A core group of six *vilas* was created in what became the captaincy of Minas Gerais: Vila do Ribeirão do Carmo, Vila Rica do Ouro Preto, Vila Real de Nossa Senhora da Conceição de Sabará (all 1711); São João del Rei (1713); Vila Nova da Rainha de Caeté (1714), São José del Rei (1718). To the north, Vila do Príncipe was established in 1714. With the move to the central western region, towns were established in Goiás (Vila Boa,1739) and Mato Grosso (Cuiabá, 1727; Vila Bela, 1752). The demography of places most associated with the Baroque was as follows: Salvador, 36,000 (1757); Vila Rica, 20,000 (1740s); Rio de Janeiro 30,000 (1760), Recife/Olinda 7,000 (1750), and São Paulo 21,000 (1765). All grew, except for Vila Rica whose population declined to 7,000 in 1804.[2] By the end of the colonial period there were a dozen cities (*cidades*) and 162 *vilas* in the colony.[3] On the eve of independence (1822), the majority of Brazil's population was still rural. Towns and cities attracted entrepreneurs, commerce developed, and merchants and traders became important in seventeenth- and eighteenth-century urban society.

Rare was the town of Portuguese America where a stone and lime church did not precede any defence more elaborate than a wooden stockade and tower and earthen ramparts. Portuguese expansion and missionary activity supported the Tridentine reforms and the Counter-Reformation. In Brazil, colonists repelled French, English and Dutch attempts to horn in on the wealth of Brazil and thereby tacitly rejected Calvinism and Lutheranism. Royal Patronage (*Padroado Real*), granted by papal bulls and briefs to the Portuguese crown, predated the establishment of crown government in Brazil. Only with royal approval could dioceses be created, ecclesiastical appointments made, and missionaries dispatched to Brazil. A papal bull of 1551 created a diocese in Salvador. In 1676 this was elevated to an archdiocese, putting it on a par with that of Goa (1557). By 1808 there were dioceses of Rio de Janeiro, Olinda, São Luís do Maranhão, Belém do Pará, São Paulo, Mariana, and prelacies of Goiás and Cuiabá. No tribunal of the Inquisition was established in Brazil, but there were 'visitations' to the colony and residents represented the Holy Office. The secular clergy were not as prominent, powerful, or wealthy as in Spanish America. Jesuits arrived in Brazil in 1549. Between that date and their expulsion in 1759, they established seminaries, colleges, schools, hospitals and pharmacies in cities and towns, and created villages (*aldeias*) for the evangelization of Amerindians. Before the end of the sixteenth century they were joined by Carmelites, Benedictines, and Franciscans and, subsequently, by other religious orders which engaged in missionary activities (Franciscans and Capuchins especially) and provided social assistance to the needy and sick, and whose monasteries and churches were prominent in the urban landscape. The Society of Jesus especially, and other religious orders in varying degrees, were driving forces in the everyday life of the colony. In the absence of a university in colonial Brazil, men of the cloth in general, and Jesuits and the monastic orders in particular, were repositories of scholarship, and owners of excellent libraries. In the case of the Society of Jesus, they were the arbiters of who received, or was denied, access to higher education in the colony.

For immigrants from Portugal, Madeira, and the Azores, and for Brazilian-born persons of Portuguese descent, Brazil was a land of opportunity. A few achieved great wealth and social prestige. There was the creation of a *nobreza da terra* ('nobility of the land'). André João Antonil, SJ, observed (1711) that to be an owner of a sugar mill in Brazil was comparable to a title of nobility in Portugal. Stock-raising could also be a source of wealth, although few achieved the prestige and

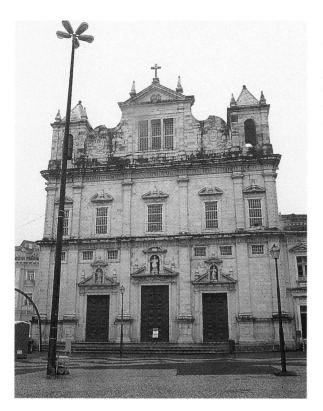

Façade of the Cathedral, Salvador, formerly the Jesuit church

São Paulo, Minas Gerais, Goiás and Mato Grosso, merchants in Rio de Janeiro were ideally situated at the point of convergence of oceanic and domestic commerce. The transfer (1763) of the capital and governor-generalship from Salvador to Rio de Janeiro enhanced their position. They achieved great wealth and invested in bullion, jewellery, precious stones, slaves, urban properties, and rural estates.[4] In 1734 it was said of Vila Rica: 'In this town live the chief merchants, whose trade and importance incomparably exceed the most thriving of the leading merchants of Portugal.'[5] Gold, diamonds, and precious stones made a few lucky entrepreneurs wealthy. There was also money to be made in financial services: making loans, advancing credit and providing insurance. These sectors engaged in capital intensive enterprises of an often highly speculative nature. Such enterprises were fraught with danger: for those few who succeeded, many others went bankrupt. Nevertheless, in the 'age of the Baroque', there was the potential for capital accumulation and disposable income.

This wealth could be expended in self-promotion and acquisition of status. Ostentatious displays of wealth, no less than destitution and poverty, were part of the warp and woof of colonial Brazil. Wealth could buy attention. Attention could bestow social prestige. The elites of Olinda were famous for the splendour of their parties. The wealthy of Salvador had urban mansions and rural plantations and were carried through the streets in their painted and gilded chairs (*palanquins*) by liveried slaves. Men and women wore an excess of gold jewellery. The wealthy of Rio de Janeiro had carriages and highly decorated chaises with lackeys and liveried coachmen. Visitors to the interior commented on lavish hospitality with tables groaning under an excess of food. Slaves, male and female, were objects to be dressed and adorned, and paraded publicly as indicators of the wealth of an owner. In the early 1730s Vila Rica was referred to as a 'golden Potosi' and a contemporary observed that 'by the wealth of its riches it is the precious pearl of Brazil'.[6] The wealthy spent lavishly on the services of tailors, goldsmiths, painters, and cabinet-makers. Vessels from Europe found ready markets in Brazil for wines, cheeses, olive oil, codfish, manufactured goods and even wigs and silk stockings. Homeward-bound Indiamen and vessels from Macao found eager buyers in Salvador and Rio de Janeiro

wealth of the great ranching dynasties of the House of Tôrre and House of Ponte. Resident on estates and plantations, these rural elites also had town houses (*solares*) and participated in the social life and governance of cities, as was the case in Salvador. Commerce afforded opportunities to entrepreneurial spirits (usually Portuguese immigrants) in the seventeenth century. Only in the eighteenth century can these be characterised as comprising merchant communities, as occurred in Salvador with the creation in 1726 of the Mesa do Bem Comum. In the course of the eighteenth century, Rio de Janeiro saw the growth of an influential and powerful merchant community. There was a hierarchy among merchants ranging from those engaged in retail and wholesale sales at the local level, in regional and coastal commerce, to an elite group who owned vessels engaged in trade to Europe, Africa, India and even Macao. The slave trade provided opportunities for wealth, but the level of profitability was unpredictable and the trade was vulnerable to warfare, disease, changing fashions in slaves, and loss of vessels. With growing markets in

for Chinese porcelains and silks, painted screens and swords from Japan, inlaid furniture, writing desks, tables, perfumes and cloths from India, and coral, ivory and ebony from east Africa. Affluent colonists spent lavishly on luxury and exotic goods from Europe and Asia, which were not merely to be cherished but to be displayed. Display was an essential part of the 'age of the Baroque'.

The elite were patrons of the arts. Rarely was this for public consumption other than in carved stonework of portals or sculpted decoration over windows on the outside of an otherwise architecturally nondescript townhouse. Examples of Baroque art were more likely to be inside residences than visible to passers-by. This was often associated with private worship. It was commonplace for wealthier householders and plantation owners to have a chapel for family worship contiguous to the main residence, or as an integral part of the main structure. Retables of stone or wood on top of an altar, statuary, religious paintings, and gilded and polychrome carved wood (*talha*) might have Baroque features. Statues and figures were often carved into the *talha*. Many houses had a hinged triptych in lieu of an altar. The richness of the ensemble could verge on the flamboyant. As for furniture, some seventeenth and eighteenth-century residences impressed visitors by the paucity and simplicity of furniture: a cupboard, beds, chairs, table, heavy chest and a modest oratory with the statue of the Virgin Mary or preferred saint. By way of contrast, others sported furniture in the Baroque style imported from Portugal and also furniture of woods indigenous to Brazil, an expression of the Baroque and especially of the Joanine period (1730–60), so named after King D. João V: chairs with arms, twisted and cabriole legs, and ball-and-claw feet, with scrolls and volutes and with grotesque faces carved on the apron; beds with headboards with carved shell designs; and chairs with high backs and leather carved with intricate designs with whorls and coats of arms.[7] There are private residences in Minas Gerais with well preserved eighteenth-century painted wooden ceilings depicting pastoral and mythological scenes, sometimes redolent with sensuality and even with a touch of the lascivious.

There was also institutional patronage of the arts. Here the lead was taken by brotherhoods of lay men and women and the third orders. In no part of the Portuguese empire did they proliferate as in Brazil. Highly coveted was election to the Santa Casa da Misericórdia and to the Third Orders of St Francis, of the Carmelites, and of St Dominic, whose membership was restricted to whites. Among parochial brotherhoods, the Most Holy Sacrament was highly regarded. Slaves, manumittees, freeborn persons of African descent, African-born and Brazilian-born, mulattos and blacks, also formed brotherhoods. Our Lady of the Rosary and St Benedict were especially venerated by persons of African descent. Depending on their resources, brotherhoods performed works of charity, gave alms, and helped the needy and sick. The numerous branches of the Misericórdia administered hospitals, provided sustenance and legal assistance for prisoners, distributed alms, cared for foundlings, provided food for the destitute, allocated dowries, buried the indigent and offered a Catholic funeral service.[8] Central to all brotherhoods was the spiritual dimension: upkeep of a church or altar, saying of masses, observance of religious festivals and holy days, and observance of the sacraments.

Not all members of the Misericórdia and the third orders were wealthy, but each institution could count some who were capable of making large donations for new buildings, preservation of the fabric, and especially for highly visible works of art. Account ledgers and minutes of meetings of their governing boards often note works commissioned in Portugal associated with the religious life of the brotherhood or third order (candlesticks, lamps, chalices, vestments, statues, even organs), architectural models and designs, contracts for construction of churches and chapels, and commissions for sculptors in stone and carvers in wood, painters of ceilings and walls in churches and sacristies, workers in gold leaf, and workers in plaster. Three specialist occupations were in high demand: carvers in wood (*entalhador*), joiners/cabinet-makers (*marceneiro*), and sculptors in stone. A single artisan might well be skilled in all three. Frequently, governing bodies needed to look no further than their own membership which numbered skilled artisans. Third orders and brotherhoods frequently upgraded and enlarged earlier and more modest churches to meet the expectations of their members and of benefactors that 'their' church should not be thought to lag

behind those of other brotherhoods with churches in the grandiose Baroque style. In Salvador, the tertiaries of St Francis remodelled and enlarged their church (built 1635) in the late seventeenth century, and its facade was overlaid with intricately carved limestone in the eighteenth century. The more prominent a brotherhood or third order, the more likely was it that the church and administrative buildings would constantly undergo revision. This was certainly the case of the Misericórdia of Salvador.[9] Some works were for the greater glory of God. Others were for the daily operations of a brotherhood. Still others were to embellish public areas, and especially a *salão nobre*, with tiles, marble, and Joanine style chairs from Portugal, and locally commissioned curtains and ornately carved tables. No tertiary or brother was unaware of the public recognition accruing to a generous benefactor, and no governing board failed to note that the degree of extravagance and magnificence of such works was a very visible measure of the prestige of a brotherhood or third order. In 1767 the Third Order of the Carmelites purchased an organ which had just arrived in Salvador 'for the glory of the divine cult and the splendour of the Order'.[10] Piety and the quest for public recognition were powerful driving forces, leading governing boards to engage in profligacy which brought them to the verge of bankruptcy. The wealthier of these brotherhoods were major patrons of the arts in colonial Brazil, and much of the cost of the glories of Baroque art was underwritten by devout lay men and women.

The Society of Jesus (prior to its expulsion in 1759), the religious orders, and the secular Church were also institutional patrons of the arts. Their financial assets derived from gifts *in vivo* or bequests of money, gold and jewellery, and plantations, country estates and urban properties which included houses, shops and wharves. Sometimes the beneficiary sold properties and applied the proceeds to institutional needs but, on other occasions, the beneficiary assumed the administration of a plantation or farm, or leased urban properties. This placed the Society of Jesus and religious orders (especially the Carmelites and Benedictines) in much the same position as any stock-raiser or plantation owner, buying and maintaining a slave labour force, being versed in technical aspects of stock-raising and agriculture, and fully cognisant of supply and demand cycles and prices in European and domestic markets. The Misericórdia and the third orders, the Society of Jesus, and monastic and conventual communities accumulated capital. In the absence of banks in the colony, they advanced or denied credit, made loans at interest, and engaged in financial services and in commerce.

The absence of a royal court in Brazil prior to 1808 and the fact that viceroys and governors-general in Brazil did not emulate the ostentatious lifestyles of their counterparts in Goa, may explain the lack of crown patronage for the arts in Brazil. For their part, municipal councils struggled to make ends meet. The number of architecturally important civic buildings is small and includes governors' palaces in Belém do Pará, Rio de Janeiro, and Vila Rica; municipal councils (Senados da Câmara) of Salvador, Mariana, and Vila Rica; and the Casa dos Contos in Vila Rica. None are exemplars of the Baroque. That church architecture prevails over civil architecture is explicable by the collective nature of patronage. There was a circular pattern. Donors made gifts and bequests to the Society of Jesus, religious orders, and prestigious third orders and brotherhoods. These resources were employed primarily in five areas: construction of new buildings and upgrading older buildings, notably churches but also administrative buildings; embellishment of the fabric of churches by ceiling and wall paintings and tiles, carved wood (which would be gilded and polychromed), retables, and curtains; purchase of statuary and organs, conducive to worship; purchase of objects associated with liturgical rituals; and purchase of vestments to dignify officiating clergy. The quality of this work, the beauty of the fabric, and the richness of the objects were such as to raise the profile and enhance the prestige of an institution. Those who were not members felt it incumbent on them to be part of such institutions, and those already members vied to make further donations. That the 'age of the Baroque' in colonial Brazil coincided with increased capital accumulation was reflected in the magnificence of churches, their fabric, and objects associated with the sacraments.

If the Jesuits counted novices and fathers with skills as artisans, as did brotherhoods and third orders, the competition to find master craftsmen within Brazil was intense. Master artisans in the building trades, painters, wood carvers,

sculptors and cabinet-makers, specialists in gilding, goldsmiths and silversmiths were in constant demand in what was a never ending cycle of construction, renovation, remodelling, and redecorating of churches and sacristies. The church of the Benedictine monastery in Rio de Janeiro was remodelled between 1670 and 1691, and there were further changes in the eighteenth century. (pp.10–11 and plate E)[11] Brotherhoods, third orders, the Jesuits, and religious orders often turned to Portugal to commission designs and works of art, to purchase marble, tiles and precut stone, and even to bring specialists, such as workers skilled in marble, to the colony. Many objects in the Baroque style in Brazilian churches and sacristies were made in Portugal: monstrances, statuary, silver-covered pulpits, crowns, haloes and altar frontals. Tiles in Baroque and Rococo styles which decorate churches and sacristies, especially in port cities, were imported, as too was much of the Baroque furniture in sacristies. Vestments embroidered with silver and gold thread and embellished with precious stones might be commissioned in Portugal or locally. The Benedictines in Rio de Janeiro commissioned an organ in Pernambuco.[12] Local artisans contributed to the creation of works of art in the Baroque style, be this in seventeenth-century Olinda and Salvador or the *barroco mineiro* which in the 1760s merged into the Rococo.

Baroque was a style of painting originating in Italy and introduced into Brazil in the 1730s. This was executed by local artists in Salvador, Pernambuco and Minas Gerais primarily, on church ceilings. Dominating such paintings is a central figure or group, on a sea of clouds, with angels, putti, and musicians in abundance, but more intriguing is how the artists create exercises in *trompe l'oeil* and in perspective. If one single form can be singled out as an expression of the Baroque in Brazilian art, it is wood carving known as *talha*, which might later be painted or covered in gold-leaf. Superb examples are the churches of the Third Order of St Francis in Recife, of the Third Order of the Carmelites in Cachoeira, and of the Benedictine monastery in Rio de Janeiro, but pride of place must go to the church of St Francis in Salvador (plate D). *Talha* appears on retables, sometimes monumental, on lateral altars and high altars, in transepts and chancels, in individual chapels or covering entire naves, and on pillars. It is characterised by its detail, by its fluidity, whorls and swirls, and by its intensity and variety of large leaves, anthropomorphic figures, acanthus foliage, monstrous figures and sometimes less than chaste putti. It is visually stunning when covered in gold-leaf as in the 'golden churches' of Recife (plate C), Rio de Janeiro, and Salvador.[13]

There is coincidence between the more important churches in the Baroque style – notably of the Jesuits, Benedictines, Carmelites, and Franciscans – and clusters of towns and cities where the Society of Jesus and religious orders were most prominent, and which also counted wealthy Misericórdias and third orders: Olinda/Recife, Salvador and the Recôncavo, and Rio de Janeiro. Away from the coast, third orders and brotherhoods played a disproportionately important role, when compared to the littoral, as patrons of the arts in São Paulo, Minas Gerais and Goiás. Religious orders, so much in evidence in coastal towns and cities, were banned in Minas Gerais by order of King D. João V. Whereas Benedictine, Franciscan, and Carmelite monasteries dominated the urban landscapes of coastal cities, this was not the case for towns and cities in the interior. This ban did not diminish (in fact, may have enhanced) the prominence of third orders in Minas Gerais. Among the glories of the *barroco mineiro* are churches of the Third Orders of the Carmelites and of St Francis in Vila Rica and of many brotherhoods, including the black brotherhoods of Our Lady of the Rosary and of São José.

Between the 1530s and 1822 between 3.5 and 5 million Africans were brought to Brazil as slaves. Slaves made up about 38% and free persons of African descent (freeborn and manumitted) about 27% of the colony's population in the early nineteenth century.[14] In many areas, persons of African birth or descent were a demographic majority, and whites in the minority. This underlines a fact which can not be overemphasised: namely, the African contribution to the art and architecture of colonial Brazil. This was twofold. The first was by the sweat of their collective brow as slaves on plantations, farms and ranches, as miners, and in the building trades; as porters, drovers, muleteers, quarrymen, boatmen and artisans; and as peddlers, ambulant sellers of food and drink and as market vendors. The wealth which financed art in the Baroque style in Brazil was largely the product of slave labour. Secondly, though designs for chapels, churches, choirs,

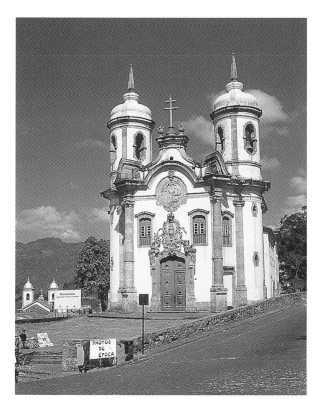

Antônio Francisco Lisboa, known as Aleijadinho (1738–1814), Church of São Francisco de Assis, Ouro Preto

retables and pulpits, and for the decoration of naves, were for the most part made by architects and master craftsmen of Portuguese birth or descent and followed Portuguese models, a few exceptions where Brazilian-born and freeborn mulattos and blacks filled these roles have been identified. The mulattos António Francisco Lisboa, better known as Aleijadinho, and Valentim da Fonseca e Silva, master of *talha*, come to mind. But, by their skills as painters and gilders, carvers in wood and stone, and as carpenters and masons, slaves and free and freed persons of African descent, African-born and Brazilian-born, were the actual executors of works of art. They worked as a team under the supervision of a master craftsman. Their identities have been lost in the sea of anonymity which is the common fate of enslaved peoples of the Americas. Oblivion was also the fate of Amerindians who worked on the building of Jesuit colleges and churches in Belém do Pará and elsewhere and who were trained as woodcarvers.

The 'age of the Baroque' included other forms of expression, of which ritual and performance were to the fore.

Often the two merged. The interior design of some colonial churches, together with boxes, tribunes, pulpits and choirs, would have been well suited to musical or theatrical spectacles. In addition to the liturgical calendar, and religious celebrations in observance of holy days and especially during Holy Week, there were special events, full of pomp and circumstance, celebrated by the church. Two examples, one in late seventeenth-century Salvador, the other in Minas Gerais at the height of the 'golden age', exemplify the baroque quality of such events.

Afonso Furtado de Castro do Rio de Mendonça, Viscount of Barbacena and governor of Brazil, died early in the morning of 26 November 1675 in Salvador. This set in motion arrangements for his lying in state, funeral and burial, and memorial mass. In the room where he died, two small steps, covered in pearl-coloured silk and trimmed with silver, led to a low platform. Dressed as a knight, the deceased lay on an ebony bed embellished with gold, with woven canopy and covered with fine coverlets, one of Indian silk, and with rich pillows. Eight wooden altars were constructed, with hangings of red velvet and richly embroidered hangings. The room was described as being 'decorated majestically, our hero placed on a triumphal although funereal throne, the altars set with grandeur, the wax tapers and twenty torches burning, the floor covered with rich Indian carpets'. Priests celebrated mass. At 3 pm participants in the funeral procession started to assemble. Banners of brotherhoods and military companies made this a 'springtime of colours'. Dignitaries and religious orders paid their last respects to the deceased. Six brothers of the Misericórdia bore the bier, covered with a rich cloth of black velvet trimmed with orange coloured brocade, and with gold fringes and tassels. The body was placed on the bier and lights 'gave life to the majesty and pomp of that great display'. The group escorting the bier left the building. Salvos were fired and the funeral procession formed and started at 6 pm. At the front was the banner of the Misericórdia, followed by poor and destitute carrying candles, more than 100 brotherhoods with standards and torches, religious orders, the cathedral chapter, and priests all bearing candles. The bier, flanked by two cavalry officers, was escorted by the brotherhood of the Misericórdia, and closely accompanied by crown judges, the

secretary of state and senior civil servants, and the lieutenant general. This contingent was followed by leading citizens of Salvador, and by infantry and artillery companies with weapons reversed and gun carriages covered in black. The populace 'great and small of the entire town' brought up the rear. To the tolling of bells and firing of salvos from the forts, the procession proceeded to the church of St Francis. Last respects were paid, and then the Misericórdia brothers placed the coffin in a tomb in the chancel. The panegyricist noted 'signs that appeared when our hero gave his soul to God, indicating that it was saved'. An elaborate edifice covered in black silk had been constructed over the tomb, the vault decorated, and the church draped in mourning. On Saturday, 20 December, in the presence of the governors, judges, and officials, the dean of the cathedral officiated at the high mass and a friar, 'celebrated among great orators for his uplifting spirit', gave the sermon which concluded this richly baroque celebration fusing church and state.[15]

On 24 May 1733, in the parish of Ouro Preto in Vila Rica, a procession accompanied the transfer of the Holy Eucharist from a temporary location in the church of the black brotherhood of Our Lady of the Rosary, on the occasion of the consecration of the new church of Nossa Senhora do Pilar. This was described by Simão Ferreira Machado, a native of Lisbon but resident in Minas Gerais, in *Triunfo Eucharistico, Exemplar da Christandade Lusitana* (Lisbon, 1734).[16] During the preceding week excitement had been building with lanterns and street decorations, flags carried through the streets, and musical performances. Decorated wooden arches spanned streets and homeowners had colourful flower boxes and hung carpets from windows. Five triumphal arches, encrusted with gold and diamonds, had been built for the processional route. The spectacle was a masterpiece of choreography. Vying for attention were dance groups representing Turks and Christians, bands of musicians (many of African descent) performing on a variety of musical instruments, and singers. There was choral and instrumental, sacred and profane, erudite and popular music. Performers were dressed in silk embroidered with gold and silver, sported colourful feathers, and were adorned with objects of gold and silver, diamonds and precious stones. This spontaneous and individualistic

outpouring of enthusiasm had to be coordinated with the formal procession: triumphal floats with allegorical figures and others drawn from Christian mythology and symbology; and the processional of priests and marching soldiers of the local garrison. The crown was represented by the Count of Galvêas, governor of Minas Gerais. There were theatrical performances, bullfights, pyrotechnic displays and feats of horsemanship. This extravagant event had rich visual and musical components; it combined orchestrated events with spontaneous outbursts of joy, and liturgical ritual and celebration of the spiritual significance of the event with profane celebrations which appealed to local elites and to the populace.

No less rich were celebrations on the arrival of a church dignitary. The inauguration of the diocese of Mariana and arrival of the first bishop in 1748 was described by the anonymous author of *Aureo Throno Episcopal* (Lisbon, 1749).[17] Dom Fr Manuel da Cruz had made the gruelling journey by land and water from Maranhão to Minas Gerais. The bishop designate, keenly aware of distress caused by the declining gold production, tried to deter local officials from 'the excessive expenditures on pomp and splendour, which the inhabitants of that gilded emporium of America are accustomed to make on such occasions'.[18] In vain. He was accompanied by dignitaries of church and state for a formal entry into Vila Rica and on his subsequent journey to Mariana, where there was a tumultuous welcome with spectacular illuminations, poetry recitals, and musical performances. For the week prior to his formal entry into the city and taking office on 28 November, buildings were illuminated, criers made announcements, and there were theatrical performances and poetry recitals. A city councillor, at his own expense, held a firework display. A garden had been created on a platform above the main street with myrtles, flowers, a working fountain and a lake. On 28 November the City Council ordered streets to be strewn with sand and flowers, and silks and tapestries hung from windows. With all due solemnity, Fr Manuel da Cruz was consecrated surrounded by church dignitaries, and then rode on a white horse surrounded by crown officials and accompanied by brotherhoods, the nobility and clergy, to be formally greeted by the Senado da Câmara.

The final solemn act was in the cathedral where the new bishop on his throne received the homage of officials of church and state. The celebrations continued until 10 December when there was an 'academic function' of public congratulation to the new bishop attended by 'all the nobility of the city' and presided over by the incumbent of the newly created position of archpriest of the cathedral. These extraordinary celebrations embraced two dimensions of the Baroque. There was the spectacular extravaganza in the streets of triumphal floats with allegorical figures, brotherhoods, horsemen, the clergy and military, with the music of tambourins, flutes, and fifes to assault the ear, and dances by Carijó indians and blacks. This was balanced by sacred choral and instrumental music, solemn masses, acts of devotion and piety, dignified and well orchestrated ceremonies, oratory of the highest quality, and appeals to the intellect by erudite sermons and declamation of poetry.

Civic events were organized by town councils. They were part of the civic calendar or marked extraordinary occasions such as the arrival of a viceroy, governor or crown magistrate. When governor Bernardo José de Lorena travelled to northern Minas Gerais in 1801, he was fêted in Tijuco by a populace delighted that he had suspended the despotic intendant and controller, but even he could not have anticipated that in the hamlet of Conceição do Serro, which counted a mere 200 hearths, there would be illuminations, a band and choral group, a farce requiring a model sailing vessel, dances, and a triumphal cart pulled by a white rhea![19] News of royal births, marriages, and deaths required public outpourings of grief or joy. Excessive expenditures by Senados da Câmara led to royal admonitions to emphasise the spiritual and sing hymns giving thanks to the Almighty instead of spending scarce funds on bullfights, displays of horsemanship and theatrical performances. In vain. Royal counsel could not compete with civic pride, and the bands marched on. One such occasion was the marriage in 1785 of the infante Dom João, the future João VI, to D. Carlota Joaquina, daughter of Charles VI of Spain. These were difficult times in Minas Gerais. Municipal coffers were low, and the treasury of the captaincy depleted. But governor Luís da Cunha e Meneses, an extrovert, ignored councillors' protests and royal admonitions. He ordered the marriage to be celebrated in the lavish old style with celebrations starting on 13 May 1786 in Vila Rica. The councillors did a dramatic *volte face*. Members of the Senado, past and present, decked themselves out in the dress of courtiers with feathered hats and capes with eye-catching silk sashes, and paraded through the streets announcing the event. The celebrations opened with a solemn mass of gratitude, at which the bishop of Mariana officiated, and later there was the procession of dignitaries along decorated streets with soldiers on parade. Buildings were illuminated. In front of the Council chambers was a display of 4,000 lights. The profane took over from the solemn in what became a street carnival. Artificial scenery and two lakes were created. There was dancing in the streets, triumphal floats, three days of horsemanship and displays by professional riders brought in for the occasion, bull fights in 'the Spanish style', theatrical performances, and three nights of opera put on by mulattos.[20]

Of a very different tone, but baroque in their solemnity and display of temporal and religious authority, were civic events with an exemplary lesson: public hangings, followed by the quartering of the body, display of the head in the main square and of other parts of the cadaver in the town. This was the fate of the leader of a revolt in Vila Rica in 1720.[21] In 1789 the *Inconfidência Mineira* failed. Some conspirators were exiled to Africa. The leader, lieutenant Joaquim José da Silva Xavier, was hanged in Rio de Janeiro. The arrival of his head in Vila Rica was celebrated in the townships of Minas Gerais with illuminated displays and a *Te Deum* in Nossa Senhora do Pilar.

Such commemorations, celebrations, and events were characterised by the religious and the profane, each to excess. They were public demonstrations of individual, collective and institutional piety, calculated to inspire awe and even fear. They were baroque in their severity, piety, ritual, orchestration, complexity, and pomp, and were appeals to the spiritual thirst of congregations as well as to their eyes and ears and, in some few cases, their intellect. Ostensibly religious celebrations could have a profane component which appealed to both the elite and the populace and which might even predominate. In social and racial terms, such celebrations were remarkably inclusive. No participant or spectator would have been unaware of the public display of the authority of the crown and

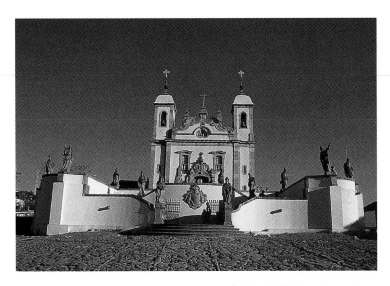

Antônio Francisco Lisboa, known as Aleijadinho (1738–1814), View of Congonhas do Campo, Minas Gerais, with stone statues of Prophets flanking the dramatic staircase leading to the church of Bom Jesus de Matosinhos

the power of the church, as represented by dignitaries of church and state, and a military presence variously evidenced by troops of the line, dragoons, or militia. The reign of Queen Maria I (1777–92, when she was declared mentally incapable), transfer of the royal court to Brazil, and celebrations in Rio de Janeiro in 1808, have a Baroque quality. The frequency and magnificence of festivals in Rio de Janeiro between 1808 and 1831, described by one historian as a 'liturgy of monarchical power', was the continuation into the period of Empire in Brazil of the style of the Baroque.[22]

That these public religious and profane celebrations were another form of the expression of the Baroque is underlined by how much they had in common with the arts in colonial Brazil. Let us take examples from the works of two celebrated artists of the *barroco mineiro*: António Francisco Lisboa (1738–1814), and Manuel da Costa Ataíde (1762–1830). The former achieved fame as a sculptor in stone and carver in wood. The latter was distinguished for his painting. Aleijadinho showed greater versatility in his choice of subjects and media for his artistic expression, the variety of his works ranging from monumental sculptures to individual statues. He was also a draughtsman. Much of his work was commissioned by brotherhoods and third orders. Ataíde likewise received many commissions from third

orders, and is primarily known for his painted ceilings in churches and chapels of Minas Gerais. Their work shared four features common to the celebrations described above. Paramount was the visual impact. Ataíde's paintings make a great impact by their colour and richness of their forms. No less do the pulpits of Aleijadinho, or his magnificent facade of the Third Order of St Francis in Vila Rica, overwhelm the viewer by the beauty of form and detail. The colour and form of the carved wooden statues of the *via crucis* at Congonhas do Campo combine to make a great visual impact. There is also a theatrical quality to their work. The twelve apostles carved in soapstone by Aleijadinho in front of the Santuário do Bom Jesus de Matosinhos in Congonhas do Campo and the statues of the Passion of Christ, carved in cedar, have a 'stage presence'.[23] The soapstone figures dominate their immediate surroundings by their authoritative presence, and an apparently understated simplicity in execution reinforces what to the onlooker is a self-confidence and sense of unassailability. The tableaux of the Passion of Christ possess a no less forceful theatrical quality, and individual statues have a power of evocation to make any actor jealous. There is a similar sense of presence in paintings by Ataíde, where the eyes of the onlooker are drawn to the forceful figures which dominate the paintings. Thirdly, in the matter of execution, as was the case with the celebrations, there are instances in the work of both artists of meticulous attention to detail on the one hand and, on the other, a willingness to sculpt or paint for the 'big picture' effect. There is an almost capricious quality alongside the rigorously formal. Finally, in both there is the juxtaposition of the sacred and the profane, where the artist gives free rein to his enthusiasm, leading to exuberance and extravagance. Ataíde, who may have used his children and their mulatto mother as models for his paintings, brings a raw sensuality to his portrayal of angels, cherubim and musicians and even to Nossa Senhora da Porciúncula, all of whom have dark complexions, in the ceiling of the nave of São Francisco de Assis in Ouro Preto.[24] (plate H) There is a Dionysian quality to some of his paintings with religious themes, reminiscent of the public celebrations.

In addition to the fine and decorative arts, and architecture, the Baroque found many forms of expression in colonial Brazil.

These included prose, verse and oratory, but here my discussion will be limited to the performing arts. Some composers, instrumentalists and singers were Brazilian-born, but their music conformed to the European tradition. Many composers were chapelmasters (*mestre de capela*) and their compositions were largely of sacred music. Particularly interesting is the presence of mulattos as composers, instrumentalists and vocalists.[25] Some who showed early musical talent were sent to Lisbon to study and then returned to Brazil. One such was Luís Álvares Pinto (1719–89) of Recife, whose treatise *Arte de solfejar* (1761) has survived, as has a *Te Deum*, but his other compositions have been lost. That a European training was not a prerequisite for success was shown by the career of another mulatto, José Maurício Nunes Garcia, born in Rio de Janeiro in 1767 and who took holy orders. He was chapelmaster of the brotherhood of São Pedro dos Clérigos and later of the cathedral of Rio de Janeiro. In addition to being a prolific composer of 237 works (including 9 masses), in 1808 he was appointed by the prince regent to be director and organist of the Royal Chapel and to give music lessons. Minas Gerais was a fertile breeding ground for mulatto composers and musicians. José Joaquim Emérico Lobo de Mesquita (1746–1805) was the son of a slave mother and Portuguese father. He himself did not become a chapelmaster but was an organist and composer whose compositions included at least five masses, six *Novenas*, four *ladainhas*, two *Magnificats*, one *Stabat Mater* and a *Te Deum*. Lobo de Mesquita was born and lived in northern Minas Gerais, but the central part of the captaincy was richest in mulatto musicians. There was Inácio Parreira Neves, chorister, composer and conductor, who composed and directed the funeral music on the occasion of the death of Dom Pedro III in 1787. Francisco Gomes da Rocha was a cantor and composer. A contemporary was Marcos Coelho Neto, composer, conductor and trumpeter. The choral arts seem to have been particularly well developed in Minas Gerais. In addition to sacred choral music, there was the profane, which included choral and instrumental concerts, as well as the very popular serenades in the Italian burlesque tradition.[26]

Popular dances, often accompanied by black musicians, and involving persons of African descent and Amerindians have been referred to above. Theatre was highly appreciated. In addition to performances on special occasions and religious theatre, there was a strong profane theatrical tradition in colonial Brazil. From the mid-seventeenth through the eighteenth century many of the plays performed were by Spanish playwrights such as Calderón de la Barca and Francisco de Rosas Zorrilla. There were comedies and one act *entremeses* in Portuguese. Performances were by local theatrical groups or peripatetic groups of actors, often mulattos. Many performances were in the open air, or on stages in a main square, but there were also 'rooms for spectacles', as in Salvador, and even theatres, as in Vila Rica and Sabará. In Diamantina, theatrical performances attracted 7–8,000 spectators. Scenery was a highlight of the more staged performances and some dramatic pieces may have been put to music. As noted, operas were presented on special occasions in Minas Gerais. Many performances seem to have incorporated various musical genres into an extravaganza of vocal and instrumental music, dance and drama.

These expressions of the Baroque in colonial Brazil possessed characteristics which crossed time and space, and were present in art – notably wood carving, sculpture and painting – and in performance, music, literature, even lifestyles; and in what may be termed the Baroque mentality. Some of the characteristics were: theatricality and sense of the dramatic; movement and fluidity; use of colour, even to the point of being garish; contrast between light and dark, between the profane and the sacred, between the predictable and the unexpected, and between the laboriously created and the spontaneous; exaggeration, ostentation, extravagance, and hyperbole; intricacy, complexity, and convolution; a raw sensuality; an appeal to the senses, especially to sight and hearing, and an appeal to the intellect. A characteristic of the Baroque was for the artist, musician, poet, orator or dramatist to engage his audience, reader or spectator, and throw down the gauntlet to participate in a sophisticated, complex and even convoluted play of forms, sounds, colours and words.

A.J.R. Russell-Wood
Herbert Baxter Adams Professor of History
The Johns Hopkins University

Notes

1 D. Alden, 'Late Colonial Brazil', in L.Bethell (ed.), *Cambridge History of Latin America*, II (Cambridge,1984) pp.627–46.

2 Ibid., pp.602–607.

3 M. L. Marcilio, 'The population of colonial Brazil', in Bethell, op. cit. p.59.

4 J. L .R. Fragoso, *Homens de grossa aventura: Acumulação e hierarquia na praça mercantil do Rio de Janeiro (1790–1830)* (Rio de Janeiro, 1992) pp.174–192, 262–273; J. L. R. Fragoso and M. Florentino, *O arcaísmo como projeto. Mercado Atlântico, sociedade agrária e elite mercantil no Rio de Janeiro, c. 1790–c.1840* (2nd edn, Rio de Janeiro, 1996) pp.71–100.

5 C. R. Boxer, *The Golden Age of Brazil, 1695–1750. Growing Pains of a Colonial Society* (Berkeley and Los Angeles, 1962) p.163.

6 Ibid., p.163.

7 P. Dias, *História da arte portuguesa no mundo (1415–1822). O espaço do Atlântico* (Lisbon, 1999) pp.479–80.

8 A. J. R. Russell-Wood, *Fidalgos and Philanthropists. The Santa Casa da Misericórdia of Bahia, 1550–1755* (Berkeley and Los Angeles, 1968).

9 M. Alves, *História da Venerável Ordem 3ª da Penitência do Seráfico Pe. São Francisco da Congregação da Bahia* (Bahia, 1948); C. Ott, *A Santa Casa de Misericórdia da Cidade do Salvador* (Rio de Janeiro, 1960).

10 A. J. R. Russell-Wood, 'Prestige, Piety and Power in Colonial Brazil. The Third Orders of Salvador', *Hispanic American Historical Review*, 69 : 1 (1989) pp.79–80.

11 Dias, op. cit. p.449.

12 Ibid., p.449.

13 Ibid., pp.456–477.

14 Alden, op. cit. p.607.

15 S. B. Schwartz, *A Governor and his Image in Baroque Brazil. The Funereal Eulogy of Afonso Furtado de Castro do Rio de Mendonça by Juan Lopes Sierra* transl. R. E. Jones (Minneapolis, 1979) pp.117–37.

16 A. Ávila, *Resíduos seiscentistas em Minas. Textos do século do ouro e as projeções do mundo barroco* (Belo Horizonte, 1967) I, pp.135–281.

17 Ibid., II.

18 Ibid., II, p.381.

19 J. F. dos Santos, *Memórias do Distrito Diamantino* (3rd edn, Rio de Janeiro, 1956) pp.264-67.

20 Ávila, op. cit., II, pp.73–4.

21 Boxer, op. cit., p.193.

22 I. L. Carvalho Souza, *Pátria coroada. O Brasil como corpo políitico autônomo, 1780–1831* (São Paulo, 1998) pp.207–81, citation p.208.

23 G. Bazin, *Aleijadinho et la sculpture baroque au Brésil* (Paris, 1963), pp.223–54, 263–76.

24 L. Coelho Frota, *Ataíde* (Lagoa, 1982) ill.4.

25 R. Stevenson, 'A Note on the Music of Colonial Brazil', in Bethell, op. cit., pp.799–802; A. J. R. Russell-Wood, *The Black Man in Slavery and Freedom in Colonial Brazil* (London, 1982) pp.100–101.

26 Ávila, op. cit., I, pp.18, 30.

Picture key for pages 29–36

A Early seventeenth-century retable from the Jesuit college in Rio de Janeiro, now in Nossa Senhora do Bom Sucesso in Rio

B The High Altar of the Cathedral, Salvador

C View of the Capela Dourada (Golden Chapel), São Francisco, Recife

D The High Altar of the church of São Francisco, Salvador

E The High Altar of the Monastery of São Bento, Rio de Janeiro

F View of the High Altar, Nossa Senhora do Carmo, Sabará

G Antônio Francisco Lisboa, known as Aleijadinho (1738–1814)
Saint Simon Stock, detail of a lateral altar, Nossa Senhora do Carmo, Sabará

H Manoel da Costa Ataíde (1762–1830)
The Virgin Mary with heavenly choirs of angels, and King David playing the harp. Detail of the ceiling painting, São Francisco de Assis, Ouro Preto

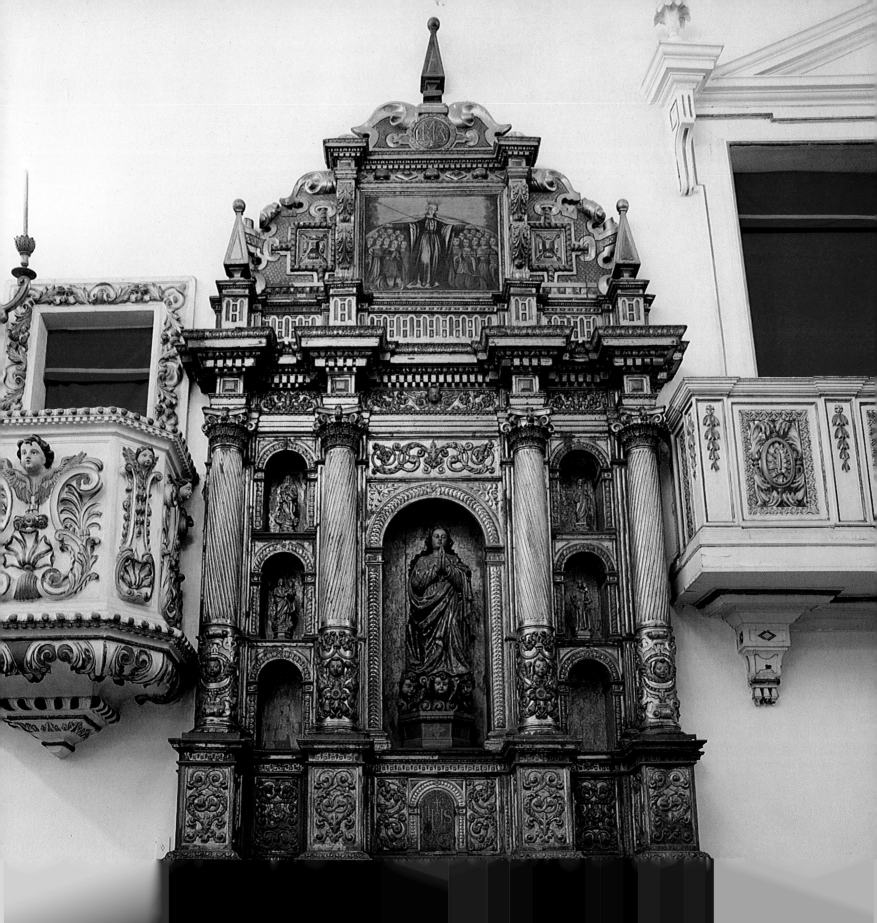

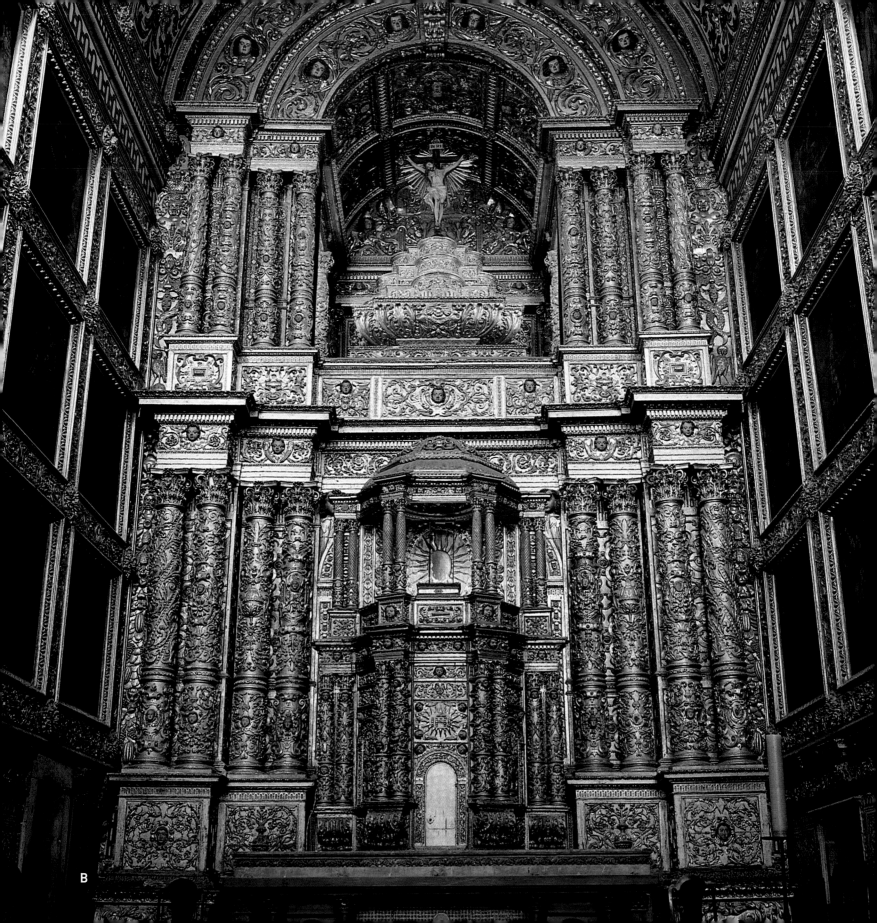

B

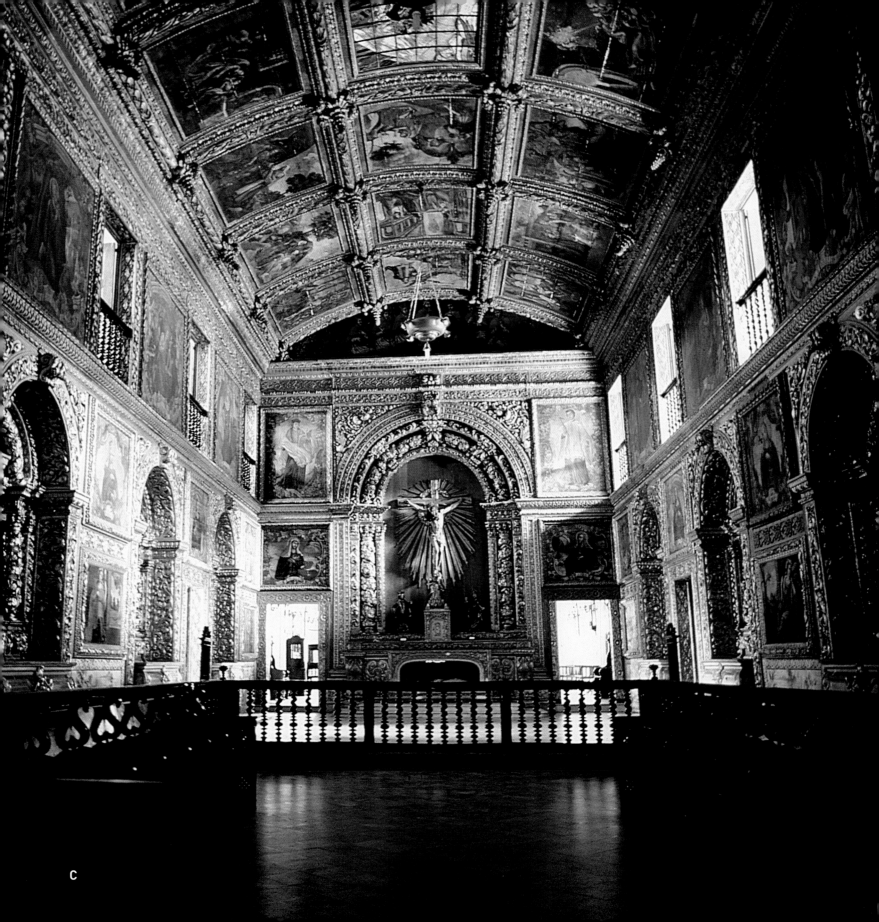

C

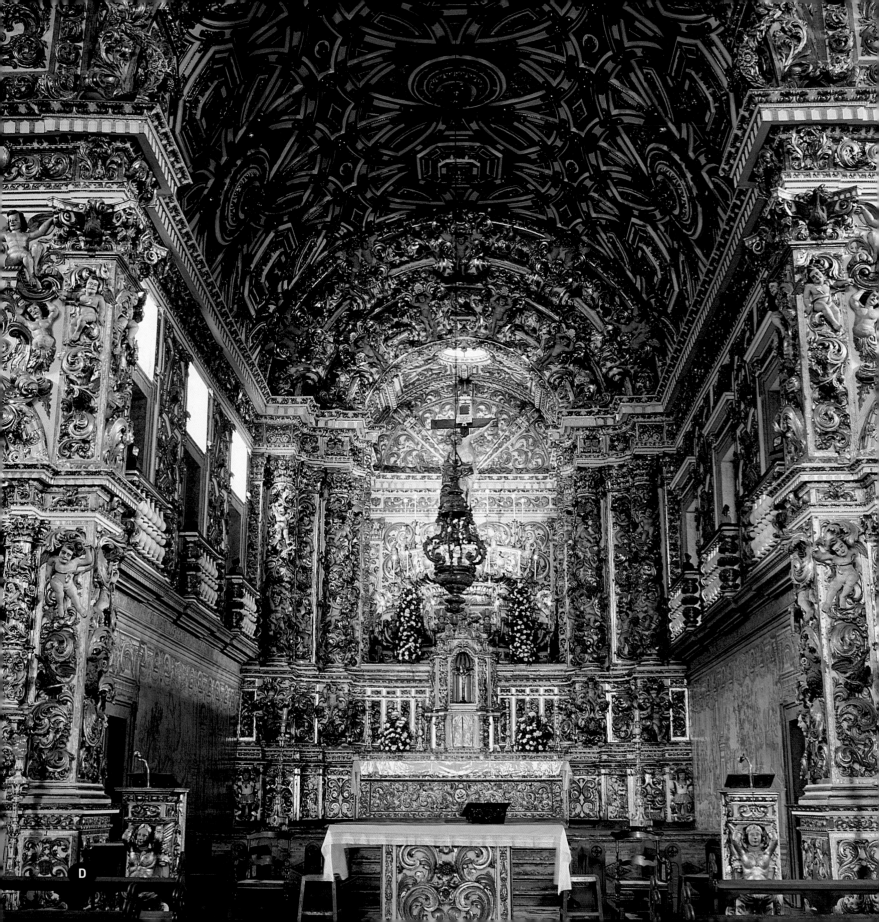

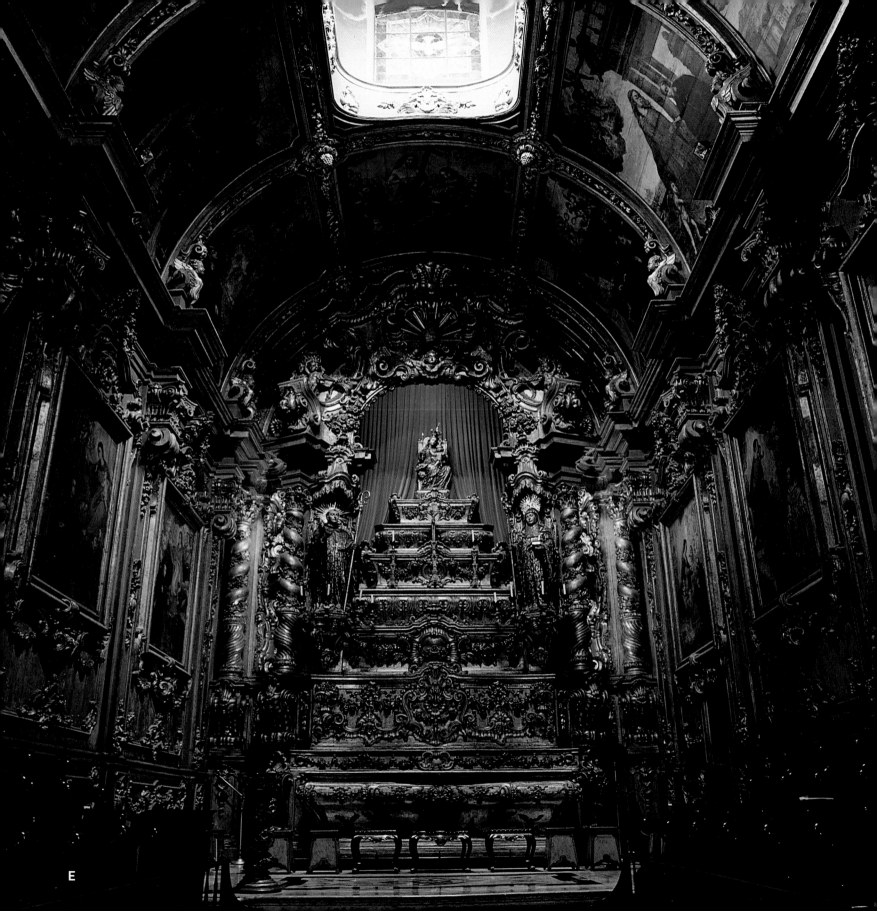

E

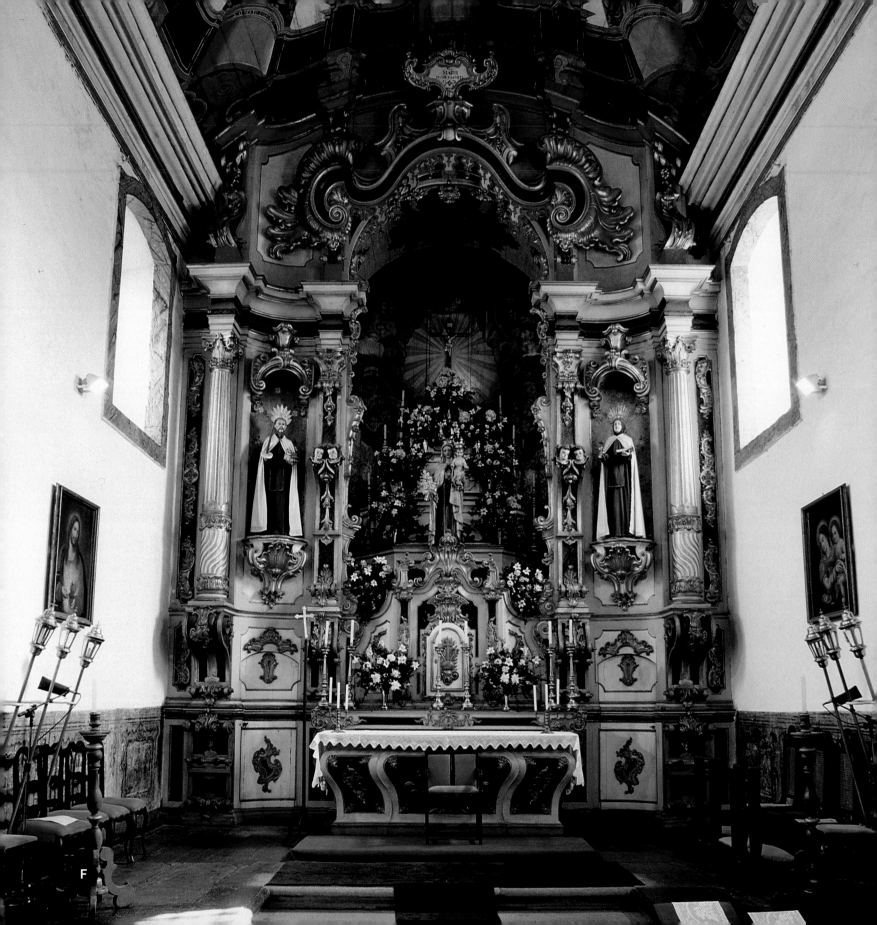

F

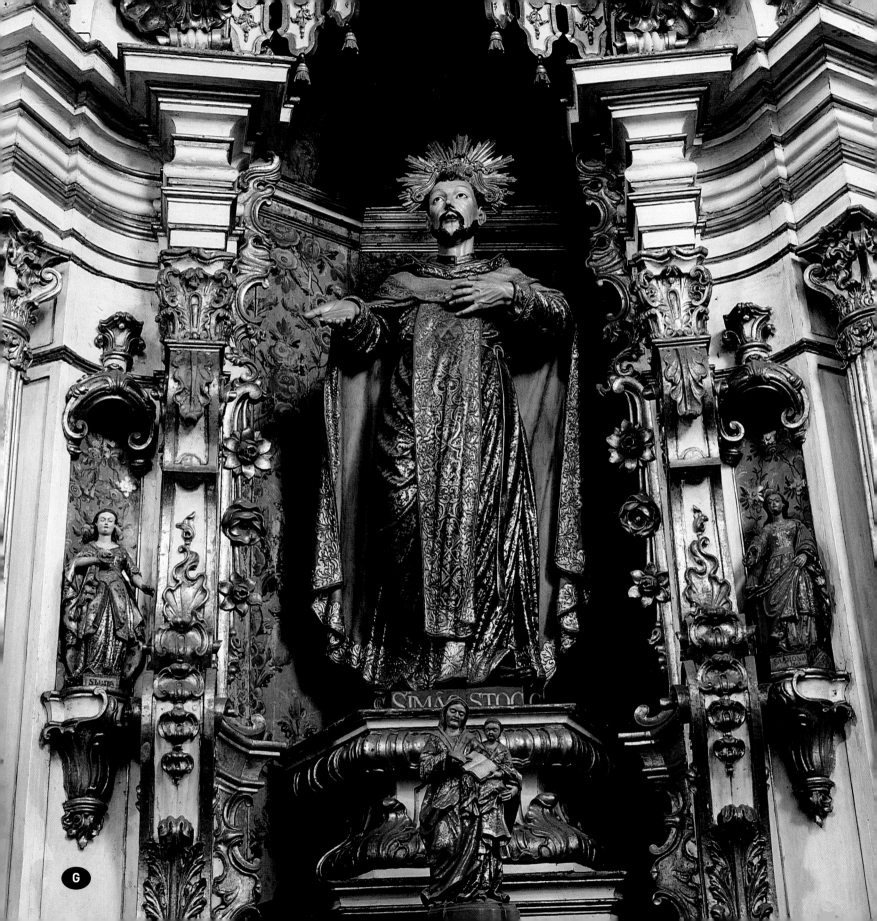

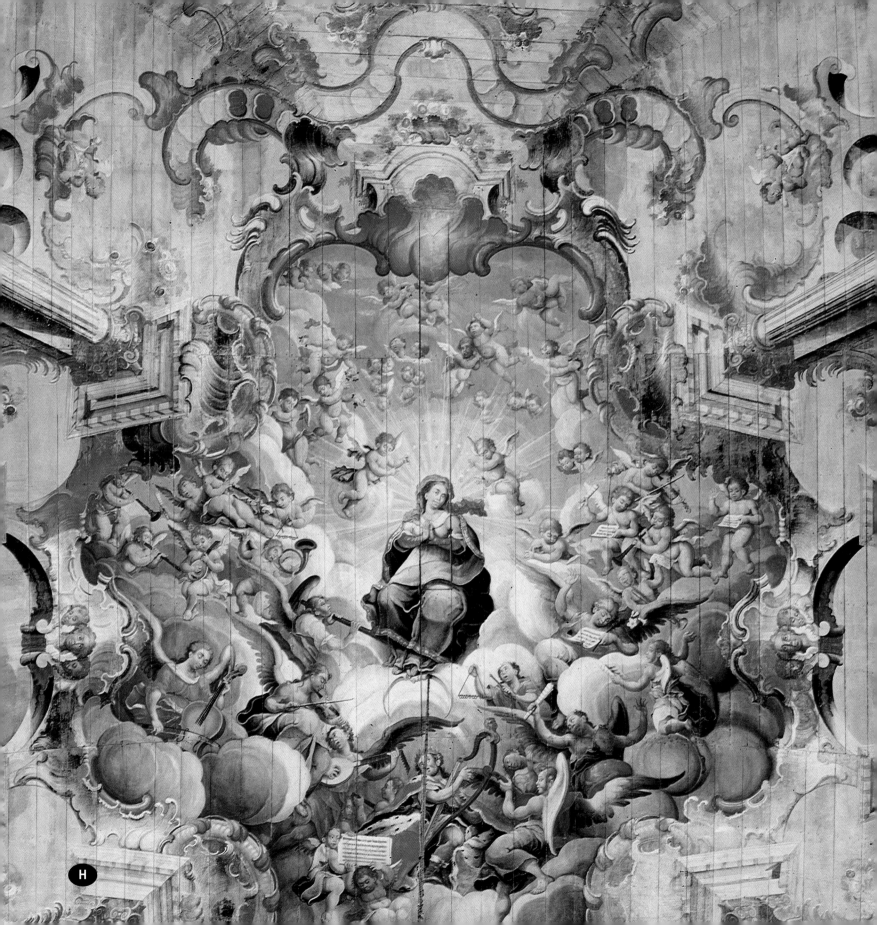

Baroque Art in Brazil: the Success of Cultural Transplantation

Historical Context and the Emergence of Brazilian Baroque Art

In order to introduce Brazilian Baroque art, it is first necessary to understand the historical context in which this art evolved, that is, within the colonising enterprise of Portugal and its partnership with the Catholic Church. Brazil, from the Portuguese perspective, represented a new arena of action – a stable colony, with a structure of land ownership and an agriculture based on monoculture, in contrast to the Portuguese colonies in the East with their trading depot structure and commercial and military basis.

From the very outset Brazilian colonisation presented difficulties due to the complicating factors produced by a territorial space of vast, continental dimensions, with totally unknown areas of harsh terrain, unwelcoming for settlement. The economic structure imposed by the colony was based on the hegemony of a slave-owning rural society. The Church was the main collaborator in the colonising process, and one must not forget its evangelising and catechetical role: the influence of the Jesuits, the education of the social elite in religious institutions, the activities of religious orders and of the varied lay associations can be seen as an expression of the mentality of this society. It is within this conduit of ideas that the ideology of the coloniser was formed, with the colony conceptualised as a territory of geographical barriers and historical inhibitions, closed to contacts outside metropolitan Portugal and protected from the contaminating risk represented by information, since there was neither a university nor a printing press in Brazil until the nineteenth century. One can add to this the symbolic image of the church as an expression of the powerful pact between State and Religion. On the other hand, the ideological formation of the settler was achieved through hostility towards the indigenous people, towards the cultural role of the enslaved African and towards miscegenation. As a consequence a religious syncretism developed as a strategy for the dominated to find both their identity and a space of tolerance in the territory of the dominant white elite. Native sentiment manifested itself as a kind of self-affirmation of a powerless society and as an element of negotiation in the face of the guardians of authority.

The art that developed in Brazil was at first simply transplanted from Portugal; later on it adapted in a search for autonomy from Portuguese stylistic models. The content of this art was basically religious, essential to nurture an ideal of faith. Its main function was bound up with the promotion and persuasion necessary for the fulfilment of the ideological programmes of the Council of Trent (1545/1563) and the Counter-Reformation, which aimed to increase the number of Catholics and fortify the faithful in the face of the Lutheran threat.

The Baroque style was part of this value system, which found its own development in Brazil, with formal and regional differences. At first there was obedience to Portuguese models in the planning of churches, the standards of building and the use of ornamental motifs, which are directly copied. Later on, Brazilian Baroque art gained autonomy, and fused with the tropical landscape with its lively colours, luminosity, and a different rhythm from that of European art.

Wood-carving and Brazilian colonial sculpture

Amongst the art production carried out by the Jesuit Order, we find the oldest surviving retables (vertically proportioned and elaborately carved altarpieces set above and behind the altar table). These can be classed as in the Mannerist style, characterised by the use of straight columns with floral motifs in the lower third, flanked by painted panels or niches with sculpted figures and crowned by a pediment in relief with a central panel. The oldest are probably the retables from the chapel of the college of Nossa Senhora da Graça in Olinda, sculpted in stone and with a simplified structure.[1] Much more

sophisticated is the set of retables from the old chapel of the Jesuit college at Rio de Janeiro,[2] presently housed in the Church of Nossa Senhora do Bom Sucesso in the same city. (plate A)

Besides the pieces made for the Jesuit colleges, the retables found in the chapels of missionary villages stand out by including elements taken from the local flora: pineapples, guavas, lilies, cashews are incorporated in the ornamentation, implying a move away from European Mannerist models. Examples include the retables found in the Chapel of São Lourenço dos Índios, in Niterói, Rio de Janeiro.[3] In São Paulo, the rural area displays a group of retables that also deviate from the Portuguese typology by using new proportions while adhering to the pattern of Mannerist pediments. This can be observed at Nossa Senhora da Conceição in Santana do Parnaíba, where the remains of a Mannerist altar from the earlier church of São Bento date from c.1700.

With regard to figures of saints, a large number of Portuguese sculptures were imported. However, some statues were made in the region, almost always with an archaic flavour. Among the earliest sculptures produced in Brazil are the St Lawrence from the chapel dedicated to that saint at Niterói and the figures of St Ignatius and St Francis Xavier from Nossa Senhora de Assunção de Anchieta, in Espírito Santo. These last two figures follow the standard production of the period, showing stiffness in the postures, an austere composition and a tendency to a simplified geometric structure. All of them are made of wood.

The making of terracotta figures, however, seems to have been numerically far more expansive in the seventeenth century. In the region of São Paulo, collections of these objects are particularly significant, to the point of characterising a whole typology, the so-called 'bandeirantes figures', which reflect the developments in wood-carving. The name bandeirantes refers to the explorers from São Paulo who ventured into the forests of Minas Gerais in quest of gold and diamonds, and who carried these images of saints with them. Their main characteristic is precisely the fact that they are made of terracotta, hollow at the back so as to be less heavy to carry about. Wherever gold was discovered, these statues provided a medium for thanking God, and the saints they represented were invoked to ensure the further success of the journey.

Besides São Paulo, the states known today as Bahia and Rio de Janeiro, and on a smaller scale Pernambuco and Espírito Santo, were also important centres for the production of terracotta figures in the seventeenth century. Working in Bahia was Frei Agostinho da Piedade: Portuguese by birth, he took his vows at the Monastery of São Bento in Salvador.[4] His activity as a sculptor was accidentally discovered by Dom Clemente da Silva Nigra, thanks to an inscription engraved on the back of a statue of Our Lady of Montserrat, now in the Museum of Sacred Art of Bahia. Since Frei Agostinho signed his pieces – an unheard-of practice in Brazil – it was possible to identify as by his hand a *St Anne Teaching the Virgin* dating from 1642 and an *Infant Christ* in Olinda, among other works (cat. 26, 48). The style of Frei Agostinho da Piedade is characterised by a pronounced Arcadianism; with geometrically structured compositions recalling the pyramidal designs of the Renaissance; the posture is hieratic and the features are placid. His work exudes great nobility and sobriety, distanced from the raptures of the Baroque in general.

From the monastery of São Bento in Rio de Janeiro[5] comes the second ceramicist monk, Frei Agostinho de Jesus, Brazilian-born but ordained in Portugal.[6] (cat. 27, 28) A third Benedictine sculptor, Frei Domingos da Conceição da Silva, working in wood-carving and wooden statuary, also deserves to be mentioned.[7] Documentation attributes to him all of the wood-carvings of the original main chapel, the arch of the crossing and the tribune, besides a certain number of statues, in the monastery of São Bento (pp.10–11 and plate E).

Amongst the achievements of the Franciscan Order is the *Capela Dourada* or Golden Chapel in the Convent at Recife, on account of the sumptuousness of its gilded wood-carvings. (plate C) These cover all of the walls and ceiling, an integral coating that is characteristic of the so-called *igrejas forradas de ouro* or 'churches covered in gold', a theme that would spread throughout the colony from the first years of the eighteenth century. Its internal decoration belongs to the Portuguese or national style, presenting pseudo-salomonic (twisted) columns, concentric arches and phytomorphic ornamentation, characterised by vine leaves. In the first decades of the eighteenth century, the wood-carvings of the

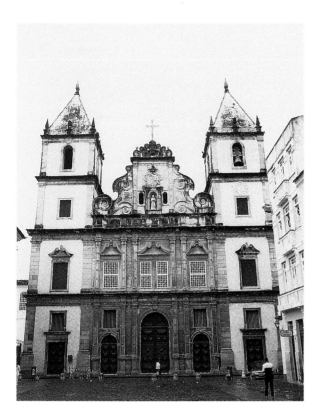

The Church of São Francisco, Salvador

retable, present mostly in the form of angels and cherubs in the crowning, or as atlantes or herms at the sides. Either in isolation or in groups, these figures are sometimes of great dimensions and rhetorical attitudes, although they are subordinate to the general rhythms of the retables, in which a sense of grandiloquence, typical of the Italian Baroque, prevails. Amongst the retables that are closer to the Portuguese D. João V style are those of the High Altar of the Cruzeiro da Sé in Salvador, or the High Altar of the Third Order of Carmelites in Cachoeira,[10] both in the area known as *Recôncavo Baiano* in Bahia (plate B).

Rococo retables were little used in Bahia, with only a few hybrid examples surviving. In these, the *rocaille* is insinuated into the Joanine wood-carving, as can be seen in the church of Nossa Senhora da Conceição da Praia in Salvador. In Pernambuco there are good examples of the Rococo style, such as the High Altar of Misericórdia in Olinda (1771) and the altar of the Cruzeiro da Sé in the same city.

With regard to statuary, two artists seem to have dominated the scene in eighteenth-century Bahia – Francisco das Chagas, known as *Cabra* (because of his mixed race) and Manuel Inácio da Costa.[11] Next to nothing is known about Francisco das Chagas. He was presumably born at the beginning of the eighteenth century, and was commissioned in 1758 by the Third Order of Carmelites in Salvador to produce three statues: a *Crucified Christ*, an *Our Lord of the Cold Stone*, and a *Christ Carrying the Cross*. None of these statues can now be identified, having probably disappeared in mid-1788. Among the surviving statues attributed to him, the *Dead Christ* is outstanding for his extraordinary expression of suffering. The *Christ of the Flagellation* by Manuel Inácio da Costa, on the other hand, presents an erect posture with the facial muscles revealing a noble acceptance of suffering. Sculpture from Bahia represents, in the late eighteenth century and early nineteenth century, a genuine school, being characterised by elegant gestures and attitudes, drapery showing refined movement, and sumptuous polychromy. This school of statuary was exported on a large scale to other areas of the country.

In spite of its less comprehensive character, since it was destined in principle only for local consumption, the sculpture

northeastern region continued to reproduce the Portuguese or national model of retables. The convent of St Francis in Salvador is a significant example of the persistence of the *igreja forrada de ouro* model, with gilded wood-carvings that totally cover the walls of the building.[8] (plate D) Among the series of retables, only the ones with representations of the cross diverge from the Portuguese or national style, with new formal elements such as the canopy above and the salomonic columns characteristic of the D. João V or Joanine style. In the northeast the great practitioners of the Joanine style were the Franciscan workshops, but only a few specimens have come down to us due to renovation and the replacement of retables with those in Rococo and Neoclassical styles. The best-preserved set is, no doubt, the one in the convent of Saint Anthony in João Pessoa, Paraíba.[9]

Besides the salomonic columns and the canopy in the crowning at the top, retables in the Joanine style are characterised by the importance accorded to the carved figures, which are integrated in the ornamentation of the

of eighteenth-century Pernambuco also shows distinctive characteristics. Firstly, it has an extraordinary technical refinement, a characteristic that would soon disappear from Bahian sculpture owing to mass production. This technical quality can be seen, above all, in the polychromy, which in the majority of cases is done by gilding the whole piece before applying the colours. A delicate work of *sgraffito*, scratching designs through the paint, reveals the gold under the geometrical or floral patterns in an intricate ornamental play. The facial expressions are more individualised, and may even reproduce the local type (*caboclo*) with almond-shaped eyes and dark skin.

Around 1730, a new element appears, the canopy or dossal – not the Joanine-style dossal, which is fully characterised, but a smaller one, usually surrounded by stylised figures of angels. This small dossal replaces the traditional archivolt on the crowning of the retables; in turn their twisted columns are alternated with a new support of four columns or pillars. Good examples of the use of these new elements, characteristic of an incipient Joanine style, can be found on the retables of the naves of the churches of Nossa Senhora do Pilar and Nossa Senhora da Conceição de Antônio Dias, both in Ouro Preto, Minas Gerais. The introduction of the D. João V style in Minas Gerais, in its full development, is due to Francisco Xavier de Brito,[12] who had already worked in the Church of Penitência in Rio de Janeiro. The work of de Brito is outstanding, above all, for his sculptural production (cat. 49). His presence is also documented in the Mother Church of Catas Altas, and the Mother Church of the Pilar in Ouro Preto.[13]

In the diamond region of Minas Gerais there are surprises like the presence of a strong regional characterisation in the making of retables, which adopt columns with straight shafts instead of salomonic ones. Also striking is the absence of carved figures in the crowning of the retable and in its supporting elements.

During the Rococo period two great sculptors emerged from Minas Gerais: Antônio Francisco Lisboa, known as Aleijadinho (cat. 40–42, 56–60)[14] and Francisco Vieira Servas. Mention should also be made of José Coelho Noronha and Jerônimo Félix Teixeira (responsible for the collateral altars of the church of Bom Jesus do Matosinhos in Congonhas), whose work has been little studied.[15] The significant body of work by Servas is distinguished by a motif in the gilded wood-carving, an arbalester (crossbow) shape completed by an imposing valance. The authorship of Francisco Vieira Servas is corroborated in the main retable of the Church of Rosário in Mariana (1770–5) and also in one of the side altars of the church of the Carmo at Sabará (1778) together with the High Altar of the same church (plate F). Other retables in the same style in the main church of Itaverava suggest his artistry. The Rococo style retable of the Aleijadinho type has a specific characteristic, as compared to those of Servas, involving the replacement of the arbalester-shaped pattern by an imposing sculptural grouping, centred on the triangulations formed by the three figures of the Holy Trinity.

With regard to individual works of sculpture by Aleijadinho, excellent examples are the statues of St John of the Cross and St Simon Stock placed in the side altars of the Church of Nossa Senhora do Carmo in Sabará (p.16 and plate G). The facial traits of the young St Simon and of the mature St John show a high degree of realism, as if sculpted after live models. In the Congonhas do Campo series by Aleijadinho (1796–1805), one sees the development from an initial realism to eventual stylisation, by the reduction of details and by the more vigorous treatment of drapery, which now forms more striking angles. In the year 1800, after completing the sets of sculptures of Passos (Stations of the Cross), Aleijadinho began work on the Prophets. Numbering twelve, these monumental stone statues, approximately life-size, are fully integrated with the architectural framework (illus. p.46).

Brazilian colonial painting

In the first phase of Brazilian colonial painting are the famous ceiling panels or *caixotões*, of which the most outstanding is the series in the sacristy of the Cathedral of Salvador, a work attributed to brother Domingos Rodrigues (1657–1706), born in Portugal. Amongst these complex decorative designs, one can see specimens of Brazilian fauna, revealing an artist sensitive to the environment where he worked. The central figures are copied from European engravings of the time, such as those found in illustrations to the Bible deriving from artists like

Raphael and Dürer. Likewise, a number of treatises, many of them anonymous, on the visual representation of biblical and secular figures by various European authors, which appeared in places ranging from Italy to the Netherlands, found their way to Brazil. Among them was the book *Para Aprender a Ler, Escrever e Contar* (*Towards reading, writing and counting*), by the Portuguese author Manuel Andrade de Figueiredo, the 1722 edition of which is held in the library of the college of Caraça, Minas Gerais.

In the church of Nossa Senhora do Rosário (in Embu, in the state of São Paulo) built at the end of the seventeenth century, a ceiling in the main chapel is decorated with *grotteschi* (ornamental motifs deriving from ancient Roman painting, popular from the early sixteenth century in Italy onwards). This work is ascribed to Father Belchior de Pontes by his biographer, Father Manoel Fonseca.[16] Curious elements in this ceiling are the pineapples that appear in the frames and in the crossing of the beams, revealing a symbolic Brazilianism. The decoration of the chapel of São Francisco da Penitência (the *Capela Dourada*, plate C) in Recife, whose painting was carried out between 1699 and 1702, includes a series of panels of outstanding quality in the ceiling and set into the walls, of uncertain origin. The Church of São Francisco in Bahia displays a ceiling of complex geometric patterns painted between 1733 and 1737, remarkable for its harmony with the church's overall decoration in gilded wood-carvings. At around the same time in Rio de Janeiro, Caetano da Costa Coelho obtained the contract for the ceiling painting of the nave of the church of the Third Order of Penitência, a work that opens up a new period in the history of painting in Brazil. This is the earliest example of illusionistic ceiling painting, or paintings with architectonic perspective, based on Roman or north Italian Baroque models.

José Joaquim da Rocha (1737–1807) was the most outstanding painter of this genre, responsible for a considerable output in Bahia. His best-known works are the ceilings of the Church Nossa Senhora da Conceição da Praia, the Church of Nossa Senhora do Rosário and the Church of Aflitos in Salvador. In Rio de Janeiro, the artistic production of Frei Ricardo do Pilar (d. 1700) who came to Brazil to work in the Monastery of São Bento, can be taken as a point of reference. He was responsible for the fourteen paintings on wood that are placed on the vault of the main chapel of the monastery church. (plate E)

In the state of São Paulo, the painter Jesuíno de Monte Carmelo stands out for his work in Itu, on the ceiling of the main chapel of the church of Nossa Senhora do Carmo. In Minas Gerais, illusionist painting finds its main expression in two personalities: the government official José Soares de Araújo,[17] to whom Diamantina owes the best of its pictorial collection, and Manoel da Costa Ataíde, a painter from Mariana who was responsible for a varied output, distributed over many cities. José Soares de Araújo's work belongs to a manner characterised by a simplified treatment of pictorial volumes, symmetrically disposed in horizontals and verticals, a style resembling that of José Joaquim da Rocha, in Bahia. The painting of the ceiling of the nave of the church of Nossa Senhora do Carmo in Diamantina of 1766 is one of the best examples of his work.

The work of Ataíde centralises the new Rococo trends in Brazil, rather than in Minas Gerais alone. Ataíde's painting functions within a concept of greater creative freedom, a delight in singing colours and dynamic compositions; illusionism is interpreted with an unheard-of mastery and facility, an illusionism already diaphanous, identifiable as Rococo. His masterpiece is, undoubtedly, the extraordinary ceiling of the Church of São Francisco de Assis at Ouro Preto (1801–12), where the daring and elegance of the pictorial idea is paired with the strength and purity of Aleijadinho's architectonic and ornamental programme (plate H). Around the central allegory of the Virgin Mary is a shifting, intricate mass of columns, angels and decorative *rocaille* forms. In the same compositional vein there are other ceilings and canvasses by his hand, with a lighter structure but an equal expressiveness and beauty, such as those in the main chapel of the Mother Church of Santo Antônio in Itaverava, the Church of Rosário dos Pretos in Mariana and the Mother Church of Santo Antônio in Santa Bárbara.

Other painters who were active in Minas Gerais included João Baptista de Figueiredo, who took part in the painting and gilding of the main chapel of the Church of São Francisco de Assis in Ouro Preto between 1773 and 1775; João Nepomuceno Correia e Castro with works in Congonhas, at the Sanctuary of

Bom Jesus de Matosinhos;[18] Joaquim Gonçalves da Rocha, the author of the ceiling panel in the nave of that church, depicting a scene from the life of Elijah;[19] and Manuel Rebelo e Souza,[20] who was responsible for the ceiling of the nave of the church of Santa Ifigênia do Alto da Cruz, in Ouro Preto.[21]

Small-scale art and popular faith

Within the domestic space of Catholicism, one lived surrounded by religious symbols and objects. These ranged from small statues of saints, engravings hanging on the walls, and *patuas* (charms) to the *oratório*, a little table-altar or domestic shrine that could house not only the patron saint of the family but also everything else that had a bearing on day-to-day devotion. *Oratórios* or domestic altars occupied significant spaces in the homes of the faithful. Some were displayed over a table in the main room, for use in both private and group functions, when the whole family would take part in important rituals such as novenas and collective prayers, while others were used more intimately in the bedrooms and alcoves. They display a great variety of form, size and decoration, reflecting the economic situation of the faithful. Many are decorated with polychromy and gilding, imitating the familiar ornamentation of Baroque churches, while others are extremely simple, no more than little cupboards, rough and barely decorated, but retaining the same function of housing the venerated saint.

The so-called 'saint's rooms' were also common, a place where all the apparatus of faith was kept, ranging from the statues of tutelary and patron saints of popular devotion to reliquaries, rosaries, candles, prayer books, etc. This space was in constant use, being considered one of the most important places in the so-called *Casas Grandes*, the large houses on the sugar-plantations of the Brazilian northeast. In Minas Gerais, saint's rooms were less common, with diverse spaces being reserved for the manifestations of the faith.

Another widespread form of popular religion in Brazil were the pieces known as ex-votos. These are small votive wooden panels, painted with a depiction of the particular miracle that occurred to someone thanks to the invocation of a patron saint. True works of art in popular taste, these pictures preserve the memory of the most common pains and sufferings of the time, be it a snake bite, an attack by bandits, an unknown illness or even a simple toothache. In the picture the scene of the sick person in bed or the place where the accident took place would be represented and above it, a vision of the vow offered in exchange for the miracle or cure requested. Below the picture would be an inscription referring to the date and the nature of the miraculous intervention. At the Sanctuary of Bom Jesus de Congonhas do Campo we have a vast display of these votive panels in what is called the 'room of miracles'.

All kinds of small-scale religious artefacts were found in churches, with the highlights being the silverware, either imported from Portugal or made more crudely in the region, and the vestments used in the celebration of mass, richly embroidered with gold thread and Christian symbols.

Other forms of the manifestation of faith: sermons and the theatre

The pulpit, the locus of preaching, surrounded in its decoration by iconographic information, stimulated the production of the most abundant sacred literature in the whole of Portugal, including its colonies. Inspired by the purposes of moral elevation, of persuasion, of ideological formation and conditioning, the pulpit also brings both poetic and historical values to the study of the colonial mentality. The colonial period was a time in which religious life functioned as more than just the confirmation of a vocation; it also guaranteed the prospect of an intellectual career (as we understand it nowadays) with its objectives of material gain and social prestige. The possibility of professional success otherwise was small, unless one were involved in the administrative structures of government or in those activities linked to mining, agriculture or commerce, more specifically in the Brazilian case, in the captaincy of Minas Gerais.

Independently of the ideological goals that surround Brazilian sacred oratory as evinced by the paradigmatic model of Father Antônio Vieira (1608–97), the most famous preacher of the period, this oratory blends together doctrinal purposes and a complex rhetoric, embellished with quotations, allusions and images almost to excess. The preaching style and the

São João del Rei, Minas Gerais

minute detailing of the sacred discourse were a constant concern of the Council of Trent. Several religious authors specialised in writing manuals of style, turning rhetoric into an art of stylistic imitation and repetition. They did not intend sacred oratory to be reduced to dialectic but rather to stimulate the inclination for the practice of a Catholic life. The discussion about the most appropriate form of language would therefore be fundamental for those who intended to practise sacred oratory. The discussion took place by means of formal contrapositions between the rhetoric of classic Hellenistic influence and Latin rhetoric, deriving from Cicero. In the case of Minas Gerais, a great number of documents have survived, sermons in which the intertextual practice is unquestionable. To see in these discourses the interlacing of other discourses, be it on the content or on the form, makes us reflect on the importance of Vieira's works as both a paradigm and thematic source for his successors in another historical moment of adaptation and development in Portuguese-Brazilian culture.

From the beginning of the colonisation process the theatre was one of Brazil's most important artistic manifestations, with its forms ranging from street performances, suitable for popular catechism, to major religious processions where all of the population was involved (either through participation in the procession or by producing costumes, floats, musical instruments and so on), while evolving towards theatrical performances in dedicated enclosed spaces.

In Minas Gerais, there was a similar phenomenon. Every festival in Minas at that time was an all-embracing spectacle, uniting mainly religion and theatre, but also involving circus presentations, puppetry and street plays in which the participation of gypsies, vagabonds and all sorts of adventurers was invariable. Apart from secular, cultured theatre, great celebrations of religious character and theatrical inspiration were developed in the region. Baroque art in all of its expressions shares much with this kind of spectacle, with its curtains, niches and narratives of piety that crowd the walls of churches. When entering a church, one realizes how much of the theatre it embodies, not only in its decoration but also in the sermons, sacred representations, plays and nativity scenes that are enacted there. One of the most important spectacles that took place in Minas Gerais during the colonial period was in São João del Rei on the occasion of the death of Don João V (1751). The Mother Church of Nossa Senhora do Pilar was the setting for a striking funeral celebration. There, similar to the fashion in Portugal or Italy, a macabre stage was created, composed of simulated columns and altars in the Baroque style and populated by skulls and skeletons. These elements were intended to express horror for the unknown future of the illustrious deceased, without losing sight of religious belief in life after death. The spectacle consisted of a series of solemn masses, recited in an atmosphere of diffused lighting, where light and darkness alternated thanks to the play of shadows caused by candlelight and torchlight. Around forty priests took part in the celebrations that also included sermons enunciated in dramatically sorrowful tones, revealing the tragic aspect of the mentality of Baroque culture.

Social and economic conditions in Minas favoured not only religious drama but also the growth of a theatrical literary genre. The Inconfidência conspirator Colonel Resende Costa displayed in his library eight volumes by Molière, three by

Racine and no less than eleven by Voltaire.[22] It is important to remember the activities of the conspirator and poet Alvarenga Peixoto, author of *Enéias in Lacio* (*Aeneas in Latium*) and translator of Scipione Maffei's tragedy *Merope*, who also encouraged Brazilian theatrical production, having requested on one occasion the sponsorship of the Viceroy for the New Opera. Silva Alvarenga became the interlocutor of Alvarenga Peixoto and rehearsed and performed *Eneias in Lacio* in Rio de Janeiro. The plays produced in the provinces by local people relied on amateur actors and directors, and scenery built with whatever resources were available, but the texts performed were of a high standard.

A locus of faith, repression and spectacle, the Baroque became integrated with Brazilian tropicality, acquiring distinctive new elements and ostentatious aspects in the process of cultural transplantation. From Italy to Portugal, and moving through the Netherlands, Baroque art achieved great success in its trajectory until arriving in Brazil, where it underwent changes in forms, models and themes and finally acquired a unique hue in a landscape that favours creation.

Cristina Ávila
Visiting Professor of History of Art,
Religious Iconography and Brazilian Culture
Federal University of Minas Gerais and Minas Gerais
Foundation of Education and Culture
(translated by Janaína Pietroluongo and revised by Myriam Ávila)

Notes

1 Precise date unknown, from the beginning of the sixteenth century.

2 This chapel was presumably built in the seventeenth century; it was torn down in the twentieth.

3 This chapel was presumably built before 1570.

4 Frei Agostinho da Piedade was presumably born towards the end of the sixteenth century.

5 The Monastery of São Bento (Saint Benedict) in Rio de Janeiro was begun in 1617; its construction was completed in the eighteenth century.

6 Frei Agostinho de Jesus was born in the early seventeenth century and died in 1661.

7 Frei Domingos da Conceição da Silva was born in 1643 and died around the beginning of the eighteenth century.

8 The Convent of São Francisco (St Francis of Assisi) in Salvador was begun in 1686; the date of its completion is unknown.

9 This group of retables dates from 1701 to 1730.

10 The Ordem Terceira do Carmo (Third Order of Carmelites) in Cachoeira was begun around 1702; the year of completion is unknown.

11 Manuel Inácio da Costa was born in 1762; the date of his death is unknown.

12 Francisco Xavier de Brito was active in Minas Gerais in the first half of the eighteenth century.

13 Both the Mother Church of Catas Altas and the Mother Church do Pilar of Ouro Preto were built in the beginning of the eighteenth century; the ornamentation of the Mother Church do Pilar was begun in 1736.

14 The date of birth of Antônio Francisco Lisboa, known as Aleijadinho, is controversial: 1730 or 1738 (the date of his baptism), which is the date now generally accepted by scholars; he died in 1814.

15 Francisco Vieira Servas, José Coelho de Noronha and Jerônimo Félix Teixeira were active in Minas Gerais in the eighteenth century; their dates of birth and death are unknown.

16 Father Belchior de Pontes was active in Embu, in São Paulo, in the mid-seventeenth century.

17 The Chief Customs Officer José Soares de Araújo was born in Braga, Portugal, in the first quarter of the eighteenth century and died in 1799.

18 João Nepomuceno Correia e Castro was born in the eighteenth century (date unknown) and died in 1795.

19 Joaquim Gonçalves da Rocha was active in Minas Gerais in the second half of the eighteenth and beginning of the nineteenth century.

20 Manuel Rebelo e Souza was active in Minas Gerais in the mid-eighteenth century.

21 Ceiling presumably from the second half of the eighteenth century.

22 'Inconfidentes' (the disloyal) was the name given to the members of the revolutionary movement dismantled by the Portuguese in 1789 that, inspired by the French Revolution, aimed at the political emancipation of Brazil.

Bibliography

Andrade, M. de, *Padre Jesuíno do Monte Carmelo* (São Paulo, 1963)

Ávila, A., Gontijo, J. M. Machado and Machado, R. G., *Barroco Mineiro: glossário de arquitetura e ornamentação* (Belo Horizonte, Rio de Janeiro and São Paulo, 1980)

Ávila, A., *O lúdico e as Projeções do Mundo Barroco* (São Paulo, 1994)

Ávila, A. and Santos, C. Ávila, *Iniciação ao Barroco Mineiro* (São Paulo, 1984)

Ávila, C., *Museu do oratório* (Belo Horizonte, 2000)

Barroco, n.1–18 (Belo Horizonte, 1969–2000)

Bazin, G., *A Arquitetura Religiosa Barroca no Brasil,* ed. M.Barata, transl. G. L. Nunes (Rio de Janeiro, 1956)

Del Negro, C., *Contribuição ao Estudo da Pintura Mineira* (Rio de Janeiro, 1978)

—, *Nova Contribuição ao Estudo de Pintura Mineira: norte de Minas: pintura dos tetos de igrejas* (Rio de Janeiro, 1978)

Etzel, E., *O Barroco no Brasil: psicologia – remanescentes em São Paulo, Goiás, Mato Grosso, Paraná, Santa Catarina, Rio Grande do Sul* (São Paulo, 1974)

Levy, H., 'A pintura colonial no Rio de Janeiro', *Revista do Serviço do Patrimônio Histórico Artístico Nacional* 6 (1942) pp.7–79

—, 'Modelos Europeus na Pintura Colonial', *Revista do Serviço do Patrimônio Histórico e Artístico Nacional* 8 (1944) pp.7–66

Martins, J., *Dicionário de Artistas e Artífices dos Séculos XVIII e XIX em Minas Gerais*, 2 vols., (Rio de Janeiro, 1974)

Oliveira, M. A. Ribeiro de., 'A pintura de perspectiva em Minas colonial', *Barroco* 10 (1979) pp.27–37

—, 'A Pintura de Perspectiva em Minas colonial: ciclo Rococó,' *Barroco* 12 (1982) pp.171–180

Ramos, A. R., 'Aspectos Estilísticos da Estatuária Religiosa no Século XVIII em Minas Gerais', *Barroco* 17 (1993/6) pp.193–203

Silva-Nigra, Dom C. M. da, *Construtores e Artistas do Mosteiro de São Bento do Rio de Janeiro*, 3 vols. (Salvador, 1950)

—, 'Sobre as Artes Plásticas na Antiga Capitania de São Vicente' in *Ensaios Paulistas* (São Paulo, 1958) pp.821–837

Valladares, C do Prado et al., *Nordeste Histórico e Monumental,* 4 vols. (Salvador, 1990)

Zanini, W. (ed). *História Geral da Arte no Brasil* (São Paulo, 1983)

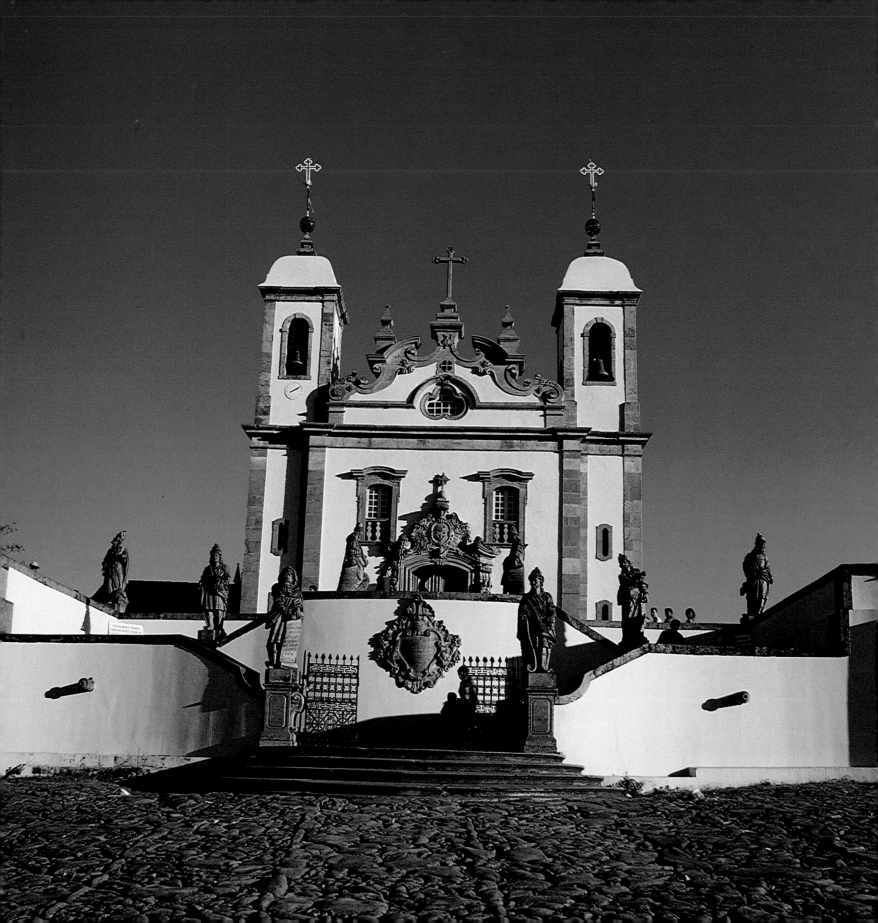

Art and Devotion in Seventeenth- and Eighteenth-Century Brazil

Il y a un luxe barbare dans les églises
Louis-François Tollenare (1816)

The whole taste and genius of the Brazilians seem to be expended in their chapels
Revd Robert Walsh (1828)

Bringing together works of art from different regions of Brazil allows for stimulating comparisons to be made in terms of techniques of carving, painting or gilding, artistic styles and approaches to particular subjects. Freed from their historical context, the works take on a new vitality in relation to each other and to the collections of European art around them. Yet what links them is the fact that all are of religious subjects or had a religious function. This essay attempts to provide a sense of where these objects were originally placed, what part they might have played in liturgical or devotional practices, and how they were viewed and perceived at the time.

A variety of opinions on the function and importance of religious images in seventeenth- and eighteenth-century Brazil can be read in, or gleaned from, the writings of the educated elite, whether clergy, well-to-do literati and government officials, or foreign travellers observing the manners and customs of the country. Far more difficult to trace are the unarticulated ideas and attitudes of the many-layered population at large, including the illiterate and barely educated. This huge majority included slaves (both African and Brazilian-born); the indigenous Amerindians; freeborn or manumitted people of African origin or descent, and those of mixed race, many of whom were traders, artisans, labourers and poor farmers; and, indeed, most of the prosperous white merchants, ranchers and plantation-owners who had little interest in books and learning – even their leisured wives and daughters rarely if ever left correspondence or diaries. As a colony, Brazil was a highly conservative society and the character of its religious life as noted by early nineteenth-century visitors had probably not changed very much over a long period – although

allowances must be made in these descriptions for Protestant and north-European disapproval of the colourful Catholicism on view. The rituals and ceremonies of the Catholic Church were central to public and social life in the seventeenth and eighteenth centuries, with festivities and commemorations marking victories and royal events as well as the feastdays of the church. Although the church implicitly condoned, or actively supported, the slave system as essential to the economy and therefore to the very existence of the colony of Brazil, it encouraged the formation of black confraternities which with their festivals and charitable activities constituted the only forum in which the individuality and humanity of slaves could be publicly recognised.

The works of art in this exhibition were originally made for display and veneration in churches and chapels, or out of doors, or in the home. In churches, sculpture was naturally seen in a rich visual context, within a play of space and movement, light and shadow, and beneath a decorated ceiling often with inset painted panels or, from the 1730s, a complex perspectival scheme; it was surrounded by carved and gilded woodwork, with paintings on the walls, decorative tiles beneath (particularly in the north-east), and opulent displays of silver, gold, colourful fabrics, candles and flowers. The Jesuit Antonio Sepp, in describing the mission church at São João Batista in the 1690s, stressed the importance of dramatic illumination with large quantities of candles: this would endow the church with splendour and majesty, and encourage devotion, as candlelight played on the colours of the sculpture, on pictures of the saints, and on the ornaments of the woodwork.[1] This emphasis on sensory stimulation was characteristic of the Counter-Reformation Church, and no matter how plain the outward appearance or how rational the ground-plan of a church might be, the interior was lavishly ornamented, providing a metaphor for the glory of heaven, or for the rich interior life of the ideal devout Christian. While the Jesuit, Benedictine and Franciscan orders in particular included in

Antônio Francisco Lisboa, known as Aleijadinho (1738–1814)
Congonhas do Campo, Minas Gerais

their number experienced architects, sculptors and painters, they also trained others in these skills as part of their strategy of making the Amerindians into useful members of an ordered Christian society. These missionaries imported large numbers of religious images to use in their teaching, which provided appropriate models. In the Jesuit missions of the south, the Guaraní Indians proved to be brilliant craftsmen, making impressive carved retables, sculptures and paintings which contemporaries saw as equalling anything produced in Europe. Sepp admired pictures which, he wrote, anyone would think were painted by the hand of Rubens. The Franciscan Agostinho da Santa Maria noted that in one of the missions of Grão Pará in the north, the young Amerindians were learning to be stonemasons, carpenters and wood-carvers, and had made a magnificent retable which was not inferior to the best made in Lisbon.[2] The visual impact of church interiors was of paramount importance, and the vocabulary employed to describe them, whether of the Jesuit Fernão Cardim viewing a wealthy plantation-owner's chapel in Bahia in the mid-1580s, the young French naval engineer François Froger admiring the Jesuit church in Salvador in the mid-1690s or the learned Benedictine Domingos de Loreto Couto writing of churches in Pernambuco in the mid-1750s, invariably included terms such as sumptuous, impressive, magnificent, beautiful, grandiose and marvellous.[3]

Apart from this rich visual context, sculpted images often had their own legends and attributed powers. In the early eighteenth century, Frei Agostinho da Santa Maria published a monumental survey of miracle-working images of the Madonna in the Portuguese empire, with two volumes dedicated to those of Brazil. In this extraordinarily detailed text, a picture of popular devotion takes shape. Many sculptures were ordered from Lisbon, whether as a sign of wealth and prestige or in order to help recreate familiar territories for immigrants to the New World. Sometimes such statues would be redecorated in Brazil, with a covering of silver leaf studded with jewels. A few notable sculptures were the survivors of shipwrecks, like the famous image of Our Lady of Grace for which an early settler, Diogo Alves (known as Caramuru) and his Amerindian wife, Caterina, built a church in Bahia; or another statue, said to be very ancient and known as Our Lady

of the Sea, which was venerated by sailors at the Hermitage of São Gonçalo.[4] Lay confraternities would commission sculpture, as when the prestigious white brotherhood of the Most Holy Sacrament at the Sé in Salvador ordered a life-sized image of Our Lady of Piedade from Lisbon ('so that it would be perfect', noted Frei Agostinho), although a large number of sculptures were made in Brazil by local artists and artisans. Confraternities often developed as a result of devotion to a particular image, as with the statue of Our Lady of the Rosary which Diogo Luis de Oliveira had ordered to be made for a small hermitage, which was later transferred to the parish church of São Antônio. Around this painted and gilded wooden sculpture, with the Virgin adorned with a silk mantle and a silver crown, a group of slaves had instituted a confraternity. Frei Agostinho recorded that this was said to be the oldest black confraternity in Bahia, and that the blacks undoubtedly exceeded the whites in devotion: while the latter were rich, the slaves, who had nothing, celebrated the Madonna as though they were wealthy.[5] Statues were sometimes given luxurious costumes and jewels – rings, crowns, jewelled drops of tears or blood, haloes shaped as solid silver rays of light – which mirrored the pomp and display of a nouveau-riche society and also suggested that one way to holiness and salvation was through the accumulation of wealth.

The presence of a particular statue could endow a church or chapel with prestige, making it a centre for pilgrimage, while also having a talismanic presence. Henry Koster told of the crowds gathering to celebrate the miracle-working Our Lady of O in Pernambuco in 1811, and of the strong feelings aroused by the removal of a statue of the Immaculate Conception from a church in Itamaraca, because of the fear that the town would remain unprotected as a result.[6] The erudite Frei Antônio de Santa Maria Jaboatão, in his history of the Franciscan order in Brazil of 1761, often refers to the role of tutelary saints, as in the protective influence of the physician-saints Cosmas and Damian in Iguaraçú during the Dutch invasion of 1633 or the plague of 1685, while he fully documents the miracle-working powers of a statue of Saint Benedict of Palermo in the Franciscan convent at Salvador.[7] The importance of miracle-working images is also attested by a rare example of secular painting from the late eighteenth

century, deriving from the tradition of the ex-voto. In two pendant scenes, João Francisco Muzi depicted the burning of the retreat-house of Nossa Senhora do Parto in Rio de Janeiro in 1789, in which the miraculous image of Our Lady was saved, and the prompt rebuilding of the institution, including the figure of the black artist and architect Valentim da Fonseca e Silva presenting the plans for the new edifice to the Viceroy.[8]

While the different religious orders promoted the cults of their founders and canonised members, other saints enjoyed great popularity in parish and confraternity churches. A variety of cults were transplanted from Portugal, to take on slightly different forms in Brazil, such as the popular St Michael of the Holy Souls, or the ubiquitous matriarchal figure of St Anne teaching the young Virgin Mary. Our Lady of the Rosary was particularly venerated by slaves; a cult promoted by the Dominicans, this may already have been familiar to Africans from the Congo where Christianity was widespread. Numerous confraternity churches were dedicated to this protective figure, and occasionally statues were shown with the head and hands painted black.[9] Loreto Couto described the church of Nossa Senhora do Rosário, erected by the black slave brotherhood in Recife: the altars included images of Our Lady of the Rosary, St Dominic, and the black saints Elesbaan (a sixth-century Ethiopian king who became a monk), Benedict of Palermo and Anthony of Catalagirona (sic; both slaves in sixteenth-century Sicily), Moses the Hermit, Iphigenia (an early Christian Nubian princess) and King Balthazar (one of the three Magi).[10]

Music and sacred oratory provided a further context for sculpture in churches, which took on an additional theatrical function on great feastdays and in Holy Week. For the missionary endeavour, music was crucial. In the light of the Counter-Reformation revival of interest in early Christianity, missionaries could view themselves as converting the world anew, with the Amerindian tribes perceived as blank pages upon which the word of God could be inscribed.[11] They quickly realized that music, song and dance were central to native cultures: in the mid-17th century António Vieira imported 'masks and rattles' to show the heathen that the Christian religion was not sad, while Manoel Gomes, in Maranhão in 1621, wrote: 'we occupied ourselves with the conversion of souls, raising crosses and churches with music and oboes that

I took with me, singing choral masses with organs'.[12] While European missionaries were familiar with the use of flowers and foliage in carved or temporary church decorations, they saw that garlands, foliage and branches had special significance for the Amerindian forest tribes whom the Jesuit missionaries in particular had settled in their model villages or aldeias. Triumphal arches were made of branches for processions and festivities, while in Pernambuco the Potiguar chief, Zorobabe, who became an ally of the Portuguese in 1603, specifically asked that victory celebrations planned in his honour should include a choir of boys singing, and the church decorated with branches.[13]

Similarly, music and dance were at the core of the culture of African slaves, who had been uprooted from their families and local traditions: in the Brazilian slave system, African nations were deliberately broken up and a group of slaves on a plantation or working in a mining district would not necessarily speak the same language or share the same religious beliefs. The Jesuit João Antonil noted in 1711 that, deprived of music and dance, slaves became melancholy and ill, while in a series of demands for a humane working life presented by rebellious slaves in 1789, one of their conditions was the freedom to sing and play as they liked.[14] The promotion of music in Catholic worship acted as an element of social control, allowing for the apparent integration of otherwise estranged groups. Similarly the sense of colour and excitement provided by candles and fireworks was encouraged as part of religious celebrations, from seventeenth-century missionary villages to early nineteenth-century Rio de Janeiro, where Hippolyte Taunay was surprised to find firecrackers marking the elevation of the host during Mass.[15] He and other visitors were struck by the splendour of churches decked out on holy days. The sceptical French cotton-buyer Louis-François Tollenare in Recife noted the 'coup de théâtre' where, accompanied by 'angelic' music, flowers floated down over the whole assembly at the Gloria, while Robert Walsh, chaplain to the British embassy at Rio de Janeiro, described church decorations for the feast of the city's patron, Saint Sebastian, which included great banks of tapers, providing 'sloping walls of light'.[16]

Sculpture and religious images could be seen in ceremonial performances, which often took place out of doors.

In Holy Week, religious dramas would be enacted in churches and on the streets: in 1809 Henry Koster was amazed and touched by a Good Friday ceremony in Pernambuco in which a friar preached a dramatic sermon to accompany a representation of the Descent from the Cross, where a life-sized image of Christ 'exceedingly well carved and painted' was at the centre of a *tableau vivant* with people dressed as soldiers, angels and saintly figures. In Rio de Janeiro in the same period John Luccock witnessed a similarly elaborate funeral of Christ, and described processions including representations of Judas and the devil with a variety of satirical and comical overtones.[17] This tradition of religious drama adapted to local concerns looked back to the earliest missionary activities in Brazil, when a statue or sacred object was often the focus of a performance. Cardim vividly described his arrival at Rio de Janeiro in 1584 and how the visiting Jesuits brought a relic of the patron saint, Sebastian, encased in a silver reliquary. Disembarking to the sound of music and acclamation from the Amerindians, and artillery salutes from the Portuguese settlers, the Jesuits moved in procession with their holy relic to the Misericórdia, where there was a theatre with an awning: there the relic was set upon a magnificent altar, and a 'devout dialogue of the martyrdom of the saint, with choruses and various richly dressed figures' was then performed, which inspired both tears and joy in the entire city. As the Jesuit church was small, a sermon was then preached at the theatre, evoking the many miracles and mercies associated with the saint, before a procession with dancing escorted the reliquary to the church.[18] *Autos sacramentales* were popular from the mid-sixteenth century: deriving from medieval mystery plays, these combinations of dialogue, music, and dance allowed the universal narratives of good and evil to be enacted, while the familiar images of saints took on human form and individual characters. In the *Auto of Saint Laurence* of *c.*1583, the principal protagonists SS Laurence and Sebastian, the Guardian Angel and Roman emperors appeared with a cast of devils, angels, birds, animals and various allegorical figures; two of the devils were identified with the Amerindian leaders who had allied themselves with the French.[19]

Meanwhile, fragments of African culture were preserved in *congadas*, or folk dramas with song, dance and dialogue on themes such as the death of a prince or tribal warfare. Our Lady of the Rosary and various saints made their appearance in these dramas, which were part of religious festivities that included the ceremonial crowning of a king or queen who would reign for a year.[20] Scholars have debated the extent to which lay confraternities and cults of saints provided an institutional setting or a protective covering for African religious cults, particularly given the structural parallels of the Virgin and saints as intercessors, and spirits or *orixás* as mediators, and the cultural parallels between the idea of saints presiding over certain activities or occupations, and the *orixás* each having charge of a certain part of nature. As John Thornton argued, Christianity provided a kind of lingua franca that joined various African religious traditions, though not replacing them.[21] In any case, manifestations of African culture were severely repressed by a white ruling minority fearful of possible rebellion. A horrified Catholic reaction to the sounds of drums, songs and chants from the slave quarters is found in Nuno Marqués Pereira's best-selling moralistic tale of 1728, sounds which the narrator compares with the fearful and sinister noises of Hell.[22] Religious processions and open-air festivities provided occasions for some forms of self-expression and emotional release, within conventions of decorum which seemed over-generous at times to foreign visitors. Thus Froger was disturbed to see a procession of the Holy Sacrament in Salvador in the mid-1690s in which, to his eyes, the sacred occasion was marred by the profanity of 'masques' and licentious dances. Le Gentil de la Barbinais described a festival of St Gonzalus in Bahia in 1715 where the small statue of the saint was removed from the church in a lively musical parade involving the clergy, men, women and slaves and, to his disquiet, passed from hand to hand; meanwhile in a theatre erected opposite the church a Spanish comedy was viewed, with the performance punctuated by hymns to the saint in a *mélange* of sacred and secular which he found unappealing.[23] On the other hand, chroniclers such as Frei Agostinho or Loreto Couto chose to emphasize the devout purposes of such lively processions and festivities, the latter for example describing the street celebrations of the black confraternity of Our Lady of the Rosary, including 'dances and

other legitimate diversions with which they devoutly cheer the people' while their singing produced great harmony which both pleased and edified. The Protestant Mrs Kindersley, in Salvador in 1764, noted that the slaves 'are as devout as the common people in our cities are profane; constant at their worship, obedient to their preceptors without scruple, and inspired with all the enthusiasm of devotion; the gilded pomp, the solemnity of processions, the mysterious rites, the fear as well as admiration of their ghostly fathers, all conspire to render them so', going on to remark acidly that 'one half of the people are governed by superstition, and the other half make use of it to govern with'.[24] The complexity and extravagance of major religious festivities have been described in A.J.R. Russell-Wood's essay above. Yet with all their exuberance, processions were regular occasions when the statues of patron saints took to the streets, not only for the sake of celebration, but also to have their protective powers extended and affirmed as they moved in a planned itinerary, meaningful to the populace, through the town or city: miracles and cures were sometimes recorded during these processions.[25]

Religious images were ubiquitous: the great sugar plantations, too large and far-flung to come under the everyday jurisdiction of bishop and clergy, all had their chapels, independent buildings appropriately ornamented; while at the initiation of the sugar-cane harvest, the mill would be blessed in the presence of statues and candles. Large farms too had chapels, usually leading off one end of the verandah, which were sometimes elaborately decorated.[26] In towns and cities, shrines on street corners or attached to the walls of buildings were common, exerting a protective aura while the tapers burning before them at night added an element of security to dark streets. Early nineteenth-century travellers often commented on these shrines: Tollenare in Recife wrote of the songs of confraternity members in front of them, and recorded problems of public order in 1787 when too many people assembled to recite the rosary and sing. In Rio de Janeiro, Luccock described images of the Virgin, standing in large glass cases with curtains drawn about them by day, which were opened in the evening and had candles placed there by pious people who, he cynically added, 'oblige their slaves to appear there and sing the Ave Maria'; shrines erected against the

walls of houses contained pictures or statues enclosed within large folding doors. Meanwhile John Mawe in Vila Rica doffed his hat in reverence as he passed a shrine with a group of devotees, recognizing a solemn moment. Loreto Couto recorded that there were forty-two street shrines or oratórios in mid-1750s Recife, and each one had a solemn novena every year in which the entire street was illuminated, with music and fireworks in honour of the Mother of God.[27]

In the home, whether in a busy city or on a large estate housing an extended family, oratórios were an essential part of everyday life. Documentary information on how they functioned is relatively scarce. Early Brazilian commentators take them for granted, so that, for example, we find Nuno Marqués Pereira's Pilgrim kneeling in prayer with the master of a fazenda in front of an oratório on the verandah, while Loreto Couto's anecdotes of exemplary virtuous women of Pernambuco involve instances of their zealous devotion in church and at home in front of oratórios.[28] Foreign visitors sometimes noted the presence of religious images in the home (and the absence of other kinds of works of art). Mrs Kindersley described the apartments of people of fashion in 1760s Salvador, where whitewashed walls displayed 'prints of our Saviour and the Virgin in strong wooden frames' and the furniture included a couch, a few wooden chairs and a crucifix: 'and yet they have jewels, and gold, and silver, and many slaves; but the arts do not flourish amongst them'. Luccock, in Rio de Janeiro some forty years later, reported that in the homes of the wealthy the reception room often had brightly painted cornices, mouldings and doorposts, while the furniture would include a wooden sofa and chairs ('some a century old') painted with flowers, with leather trunks and chests in the bedrooms; 'sometimes to these is added a small table holding some of the ensigns of religion, and instruments used in its ceremonies'. In his travels, he stayed at farmhouses where oratórios were common, for instance in one prosperous farmer's thatched dwelling, the principal apartment had 'clumsy' tables and benches, chests and leather boxes; on a chest of drawers stood a cupboard 'with folding doors, containing a crucifix decorated with silver and artificial flowers, and beheld through a pane of glass. When we entered the room, the Penates were exposed to view, but soon afterward

the master of the house, probably observing that the exhibition attracted little notice, made a respectful bow to the image, and closed its doors'. Tollenare in Pernambuco admired the pretty houses of the farmers set amidst fruit-trees, where 'one saw hardly any furniture in the interior, but always observed the ornate niche housing the madonnas and patron saints of the family. This replaces the fetishes of the black man, or the Lares of the ancients'.[29] Heavy furniture was unnecessary in a hot climate, where a hammock was more comfortable and practical than a sofa, and visitors like Koster and Luccock noted the relatively bare and simple surroundings in which plantation owners, merchants and farmers lived. (Koster was struck by the fact that even the governor's palace in Ceará had plain, whitewashed walls.) Wealth and social status were visible in the size of an estate, the numbers of slaves and dependants, and the ubiquity of gold or silver: even in a bare *fazenda* a silver basin could be produced for visitors to wash their hands, and in the most dilapidated of residences a solid silver tea-service could be found. In his comments to one of his illustrations of city life, *Troperos of Muleteers,* Henry Chamberlain noted that despite their rough attire, muleteers could sport solid silver bits and trappings.[30]

Spending on personal display and ephemeral events, rather than on pictures or ornaments for the home, had a long tradition in Brazil. Gabriel Soares de Sousa recorded the expensive dresses, the silver dinner services and the gold jewellery of the rich in Salvador in 1587, and the merchant and sugar planter Ambrósio Fernandes Brandão wrote *c.*1618 of the ostentatious lifestyle of his peers in Olinda, where men had richly caparisoned horses and liveries, costly clothing and every four days lavished money on bullfights, jousts and other entertainments. Inventories of plantation owners in the northeast would include fine furniture, clothing, silver, jewellery, some religious images and few books (except for devotional literature); yet the Dutch apparently found little booty in Bahia in 1624.[31] Amedée François Frezier was struck by the ornaments of massive gold the women wore in 1690s Salvador, while female slaves were adorned with gold chains, rings, pendants and crosses. In the cities of the north east from the late seventeenth century, some of the very wealthy had their reception rooms and chapels adorned with Portuguese

tiles: in the Palácio Saldanha in Salvador tales from Ovid graced the main reception room.[32] From a series of mid-eighteenth-century inventories in São Paulo, a pattern emerges of the houses of the well-to-do, enjoying in their main reception rooms a jacaranda sofa, a mirror, some chairs and a rug or mat, while the bare walls might host a devotional picture or a statue of a saint; invariably there was an *oratório* with statues of the Madonna, patron saints of the family, the Crucifixion and perhaps also the Infant Christ. In the wealthiest homes, a priest would be paid to conduct masses, weddings and baptisms in front of a grand *oratório*, and such houses would also boast an expensive wall-clock, an array of silverware and some 'porcellana da India'. Some of the houses of a small elite in 1770s and 1780s Minas Gerais displayed painted ceilings with allegorical or arcadian subjects, still rare in this period.[33] As Brazil's ports opened up to foreign trade in the early nineteenth century, travellers commented on the fine Wedgwood services and other English consumer goods; Maria Graham, the future Lady Callcott, saw in a house in Rio de Janeiro in 1821 'a handsome piano of Broadwood's' and she also noted a long table containing an elaborate crib, 'ministering angels, three kings, and all, with moss, artificial flowers, shells and beads, smothered in gauze and tiffany, bespangled with gold and silver, San Antonio and St Christopher being in attendance on the right and left'.[34]

Many *oratórios* were portable, or were small enough to wear. In the backlands, priests travelled to bring the sacraments to scattered settlements and farms, bearing small altars and liturgical vessels. In the illustrated views of city life produced by Chamberlain and by Jean-Baptiste Debret, details such as an old beggar with an *oratório* around his neck promising to pray for the souls of those who give alms, or a negro woman kissing an image of the Immaculate Conception carried by a confraternity member can easily be found, testifying to the intricate meshing of popular devotion with everyday life.[35] The tradition of carrying and wearing images was an old one: in the 1690s Frézier criticized the white merchants of Salvador for their show of religion, wearing an image of St Anthony on the breast or hanging around the neck, while treating their slaves with cruelty. Accounts of the great Amerindian military leader Antônio Poti, known as Camarão,

who fought against the Dutch, stress his Catholicism and the fact that he wore a little *oratório* with images of Christ and the Virgin which he would kiss with great devotion.[36] The familiar treatment of religious images, including touching and kissing them, was an age-old practice. A sense of the direct, intimate relationship between individuals and the sacred, represented by images, emerges from the proceedings of the visits of the Inquisition to Brazil in the late sixteenth and early seventeenth centuries. Favours were asked and bargains were struck; the statue or crucifix might be punished or abused if requests were not granted. In the Inquisition's avid pursuit of witchcraft and magic in northeastern Brazil, the use of small statues of the Virgin in rites of divination, and of relics or images of the saints as protective talismans, is colourfully attested. Popular religion was to become a topic of interest for early nineteenth-century observers of customs and folklore: for instance Debret recorded how St Anthony might be punished by having the Infant Christ removed from his embrace if a petition were not successful. The ingrained habit of invoking the Virgin and saints (even by a hardened *bandeirante* in the outback in 1722) must have been fuelled by the sheer ubiquity and familiarity of statues of sacred figures in the home, on streets and in churches.[37]

The sculptures and domestic altarpieces in this exhibition can be viewed in purely formal and technical terms, as works of art that form part of a tradition of polychrome sculpture in Brazil, which has its own stylistic characteristics and internal development, and which can also be related to the sculptural traditions of Portugal and Spain. However, each of these material objects had an individual existence as a focus of veneration, both private and public, vocal and silent, by a variety of different individuals in a many-layered society. The ceremonial and performative uses of statues in the rituals and festivities of the church on the one hand, and the familiar dialogues with sacred images in the home on the other, are vital aspects of religious life in Brazil in the seventeenth and eighteenth centuries, where art and devotion were inseparably intertwined.

Catherine Whistler
Assistant Keeper
Ashmolean Museum

Notes

1 B. Santos de Oliveira, *Espaçao e estratégia: Consideraçoes sobre a arquitetura dos Jesuítas no Brasil* (Rio de Janeiro, 1988) p.52; M. A. Ribeiro de Oliveira, 'The Religious Image in Brazil', in *Arte Barroco, Mostra do Redescobrimento* (São Paulo, 2000) pp.36–79, with bibliography; J. M. dos Santos Simões, *Azulejaria Portuguesa no Brasil* (Lisbon, 1965).

2 Santos de Oliveira, op. cit., p.26; G. Bailey, *Art and the Jesuit Missions in Asia and Latin America 1542–1773* (Toronto, 2000) pp.155–6; J. Hemming, *Red Gold. The Conquest of the Brazilian Indians, 1500–1760* (2nd rev. edn, Cambridge, Mass., 1995) pp.464, 468; Frei Agostinho da Santa Maria, *Santuario Mariano* (Lisbon, 1707–22) IX, p.396.

3 F. Cardim, *Tratados da terra e gente do Brasil* (Belo Horizonte, 1980) p.154; F. Froger, *Relation d'un voyage fait en 1695, 1696 et 1697 aux côtes d'Afrique, Détroit de Magellan, Brésil, Cayenne et Isles Antilles* (Paris, 1698) pp.137–40; D. de Loreto Couto, *Desagravos do Brasil e glorias de Pernambuco* (Rio de Janeiro, 1904) p.157.

4 Frei Agostinho, op. cit., IX, pp.7, 55.

5 Ibid., IX, pp.27, 60.

6 H. Koster, *Travels in Brazil* (2nd edn, London, 1817) I, pp.364–7 and II, pp.82–5.

7 Frei Antõnio de Santa Maria Jaboatão, *Novo orbe seráfico Brasílico ou Crónica dos frades menores da Província do Brasil* (Rio de Janeiro, 1858–62) II, pp.338–9; I.2, pp.91–95.

8 C. P. Valladares, *Rio Barroco* (Rio de Janeiro, 1978) I, pls.397–404; T. Costa Pestana, 'O Quadro sobre a Reconstrução do Recolhimento e Igreja de Nossa Senhora do Parto – João Francisco Muzi', *Barroco* 17 (1993/6), pp.107–13.

9 Koster, op. cit., II, p.240.

10 Loreto Couto, op. cit., p.158.

11 As Manoel de Nóbrega famously wrote in 1549; Hemming, op. cit., p.99.

12 C. R. Boxer, *A Great Luso-Brazilian Figure: Padre António Vieira S.J.* (London, 1957) p.20; Hemming, op. cit., p.117; see also P. Castagna, 'The Use of Music by the Jesuits in the Conversion of the Indigenous Peoples of Brazil', in J. O'Malley (ed.), *The Jesuits, Cultures, Sciences and the Arts 1540–1773* (Toronto, 1999) pp.641–58.

13 Bailey, op. cit., p.155 for a 1643 source; Hemming, op. cit., p.173.

14 R. Conrad, *Children of God's Fire. A Documentary History of Black Slavery in Brazil* (Princeton, 1983) p.59; S. B. Schwartz, *Sugar Plantations in the Formation of Brazilian Society. Bahia, 1550–1835* (Cambridge, 1985) pp.158–9.

15 Hemming, op. cit., p.117; H. Taunay and F. Denis, *Le Brésil ou histoire, moeurs, usages et coutumes des habitans de ce royaume* (Paris, 1822) I, p.97.

16 L-F. Tollenare, *Notes dominicales prises pendant un voyage en Portugal et au Brésil en 1816, 1817 et 1818*, ed. L. Bourdon (Paris, 1971) II, p.469; R. Walsh, *Notices of Brazil in 1828 and 1829* (London, 1830) I, p.378.

17 Koster, op. cit., I, pp.27–8; J. Luccock, *Notes on Rio de Janeiro and the Southern Parts of Brazil Taken During a Residence of Ten Years in that Country from 1808 to 1818* (London, 1820) pp.191–2.

18 Cardim, op. cit., p.169.

19 O. Fernándes, 'José de Anchieta and Early Theatre Activity in Brazil', *Luso-Brazilian Review* 15:1 (1978) pp.33–5; R. Vainfas, *Trópico dos Pecados: moral, sexualidade e Inquisição no Brasil colonial* (Rio de Janeiro, 1989) p.24.

20 R. Bastide, *The African Religions of Brazil. Towards a Sociology of Interpenetration of Civilizations*, transl. H. Sebba (Baltimore, 1978) pp.120–5; J. Scarano, *Devoção e Escravidão* (São Paulo, 1976) pp.45–6; L.M. Martins, 'Gestures of Memory. Transplanting Black African Networks', in B. McGuirk and S. Ribeiro da Oliveira (eds.), *Brazil and the Discovery of America. Narrative, History, Fiction 1492–1992* (Lewiston, New York, 1996) pp.103–112.

21 See Bastide, op. cit., p.262; K. M. de Queirós Mattoso, *To Be a Slave in Brazil 1550–1888*, transl. A. Goldhammer (New Brunswick, 1986) pp.126–30; P. A. Mulvey, 'Black brothers and sisters: membership in the black lay brotherhoods of colonial Brazil', *Luso-Brazilian Review* 17:2 (1980) pp.260–2; J. Thornton, *Africa and Africans in the Making of the Atlantic World* (2nd rev. edn, Cambridge, 1998) p.268.

22 N. Marqués Pereira, *Compêndio narrativo do peregrino da América* (Lisbon, 1728) p.115. On repression, see A. J. R. Russell-Wood, *The Black Man in Slavery and Freedom in Colonial Brazil* (London, 1982) especially pp.96–8.

23 Froger, op. cit., p.131; L. G.de la Barbinais, *Nouveau voyage autour du monde* (Paris, 1727) III, pp.216–9.

24 Loreto Couto, op. cit., pp.158–9; (Mrs) N. Kindersley, *Letters from the Island of Teneriffe, Brazil, the Cape of Good Hope, and the East Indies* (London, 1777) pp.50–51.

25 M. A. del Priore, *Festas e utopias no Brasil colonial* (São Paulo, 1994) p.68.

26 Koster, op. cit., I, p.395; Schwartz, op. cit., pp.285–6; S. de Mello, *Barroco Mineiro* (São Paulo, 1985) p.232–4.

27 Tollenare, op. cit., II, p.482; Luccock, op. cit., p.64; J. Mawe, *Travels in the Interior of Brazil particularly in the Gold and Diamond Districts* (London, 1812) p.166; Loreto Couto, op. cit., p.159.

28 Pereira, op. cit., p.122; Loreto Couto, op. cit., pp.509, 513.

29 Kindersley, op. cit., pp.33–34; Luccock, op. cit., pp.120, 196; Tollenare, op. cit., II, p.350.

30 Koster, op. cit., I, pp.200, 227, 327; H. Chamberlain, *Views and Costumes of the City and Neighbourhood of Rio de Janeiro* (London, 1822).

31 G. S. de Sousa, *Tratado Descritivo do Brasil em 1587*, ed. F.A. de Varnhagen (4th rev.ed., São Paulo, 1971) pp.139–40; A. F. Brandão, *Dialogues of the Great Things of Brazil*, transl. and ed. by F. H. Hall, W. F. Harrison, D. W. Welker (Albuquerque, 1987) p.146; Schwartz, op. cit., pp.216–7, 227.

32 Santos Simões, op. cit., pp.119–22; A. F. Frézier, *Relation du voyage de la mer du Sud aux côtes du Chily et du Perou, fait pendant les années 1712, 1723 et 1714* (Paris, 1716) p.278.

33 A. d'E. Taunay, 'Aspectos da vida setecentista Brasileira, sobretudo em S.Paulo', *Annaes do Museu Paulista* I (1922) pp.328–30; Mello, op. cit., p.116; M. A. Ribeiro de Oliveira and A. Pereira da Silva, 'Pintura', in D. Bayón and M. Marx, *Historia del arte colonial sudamericano* (Barcelona, 1990) pp.404–5.

34 Mawe, op. cit., p.225; M. Graham, *Journal of a Voyage to Brazil and Residence There During Part of the Years 1821, 1822, 1823* (London, 1824) p.127; on cribs, E. Etzel, *Imagem sacra brasileira* (São Paulo, 1984) pp.120–1.

35 Koster, op. cit., I, pp.132–3; Chamberlain, op. cit., *Largo da Glória*; J. B. Debret, *Voyage pittoresque et historique au Brésil ou Séjour d'un Artiste Français au Brésil depuis 1816 jusqu'en 1831* (Paris, 1834–9) III, pl. 4, p.122.

36 Frézier, op. cit., p.301; Hemming, op. cit., pp.312–4 and Loreto Couto, op. cit., pp.341–3.

37 P. Aufderheide, 'True Confessions: The Inquisition and Social Attitudes in Brazil at the Turn of the XVII Century', *Luso-Brazilian Review* 10:2 (1973) pp.208–40; L. de Mello e Sousa, *O Diabo e a terra de Santa Cruz. Feitiçaria e religiosidade popular no Brasil colonial* (São Paulo, 1987) pp.109, 118–21, 162; Debret, op. cit., III pp.43–5; Hemming, op. cit., p.389.

Catalogue

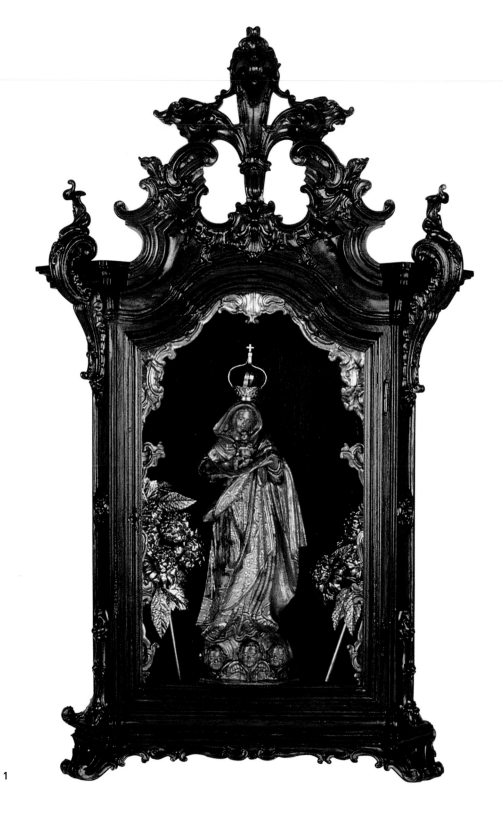

1

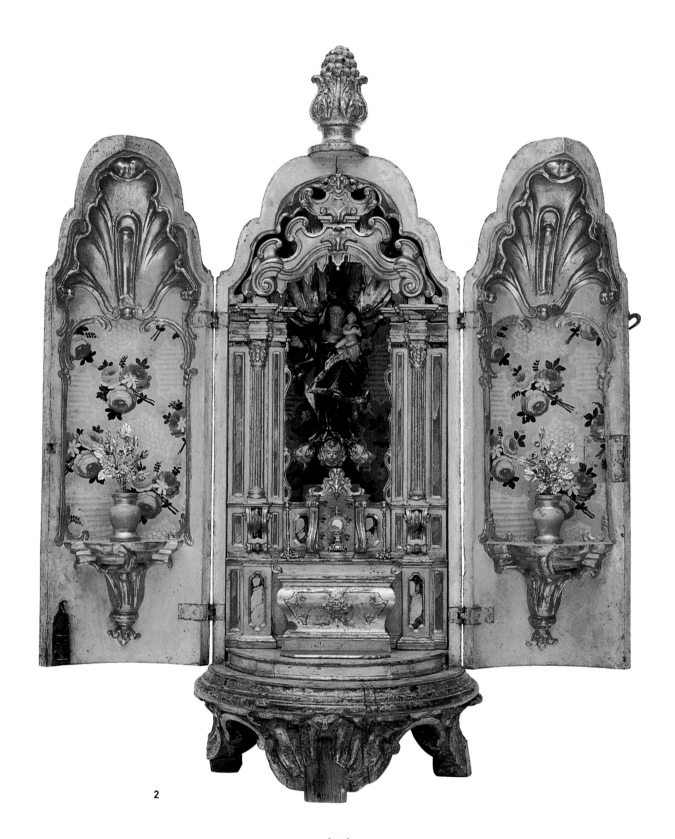

2

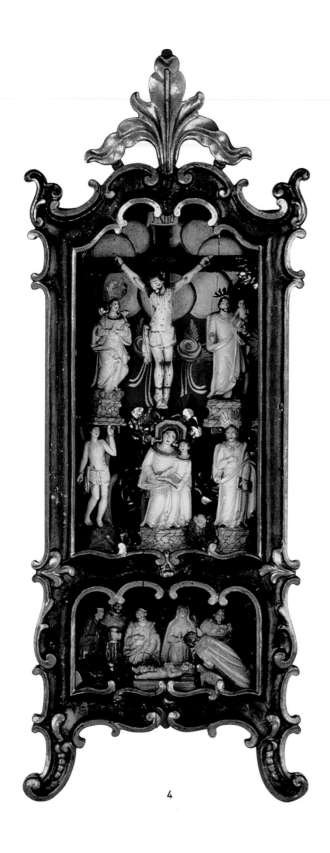

4

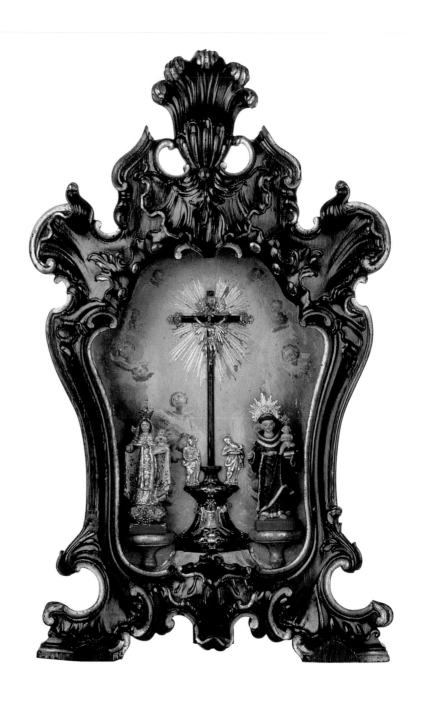

6

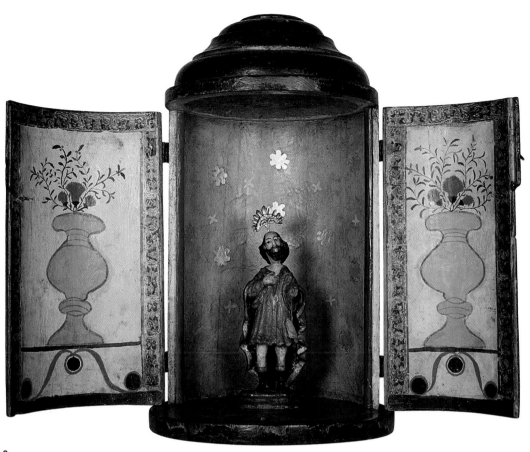

3

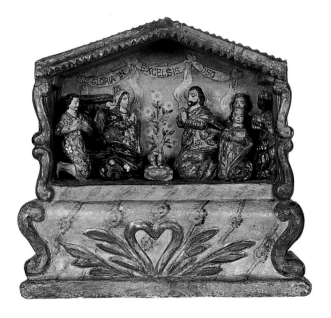

5

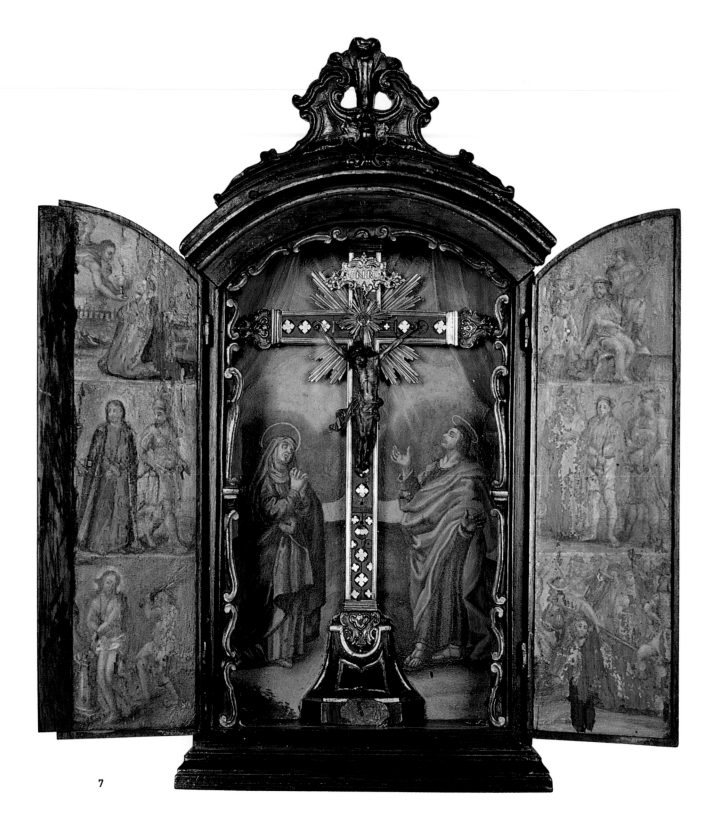

7

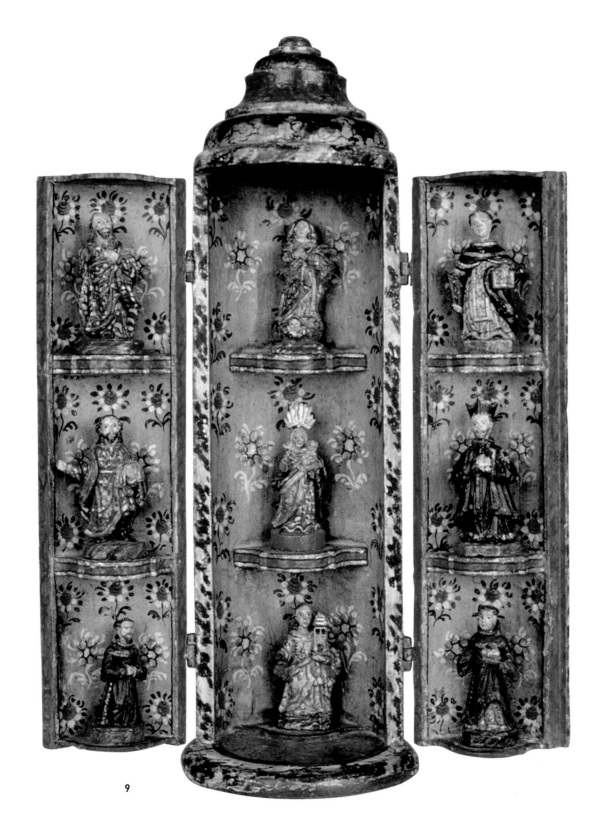

9

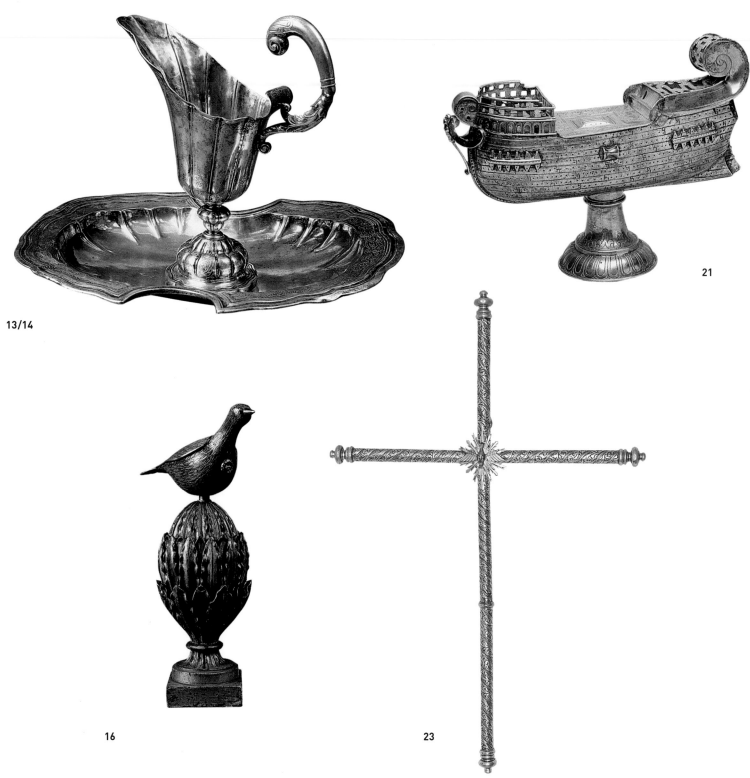

13/14

21

16

23

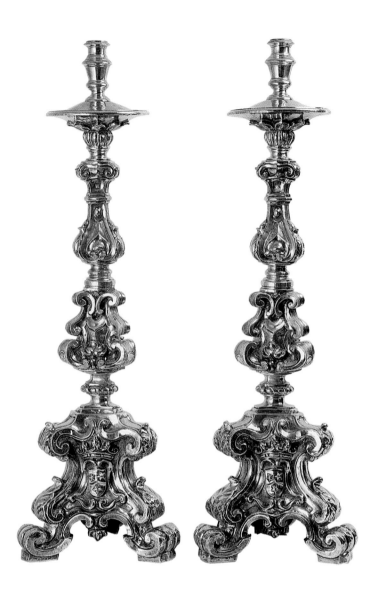

24

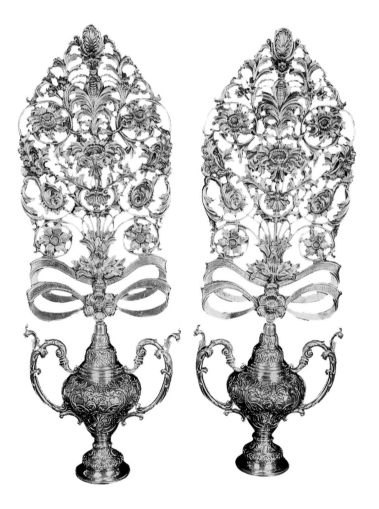

25

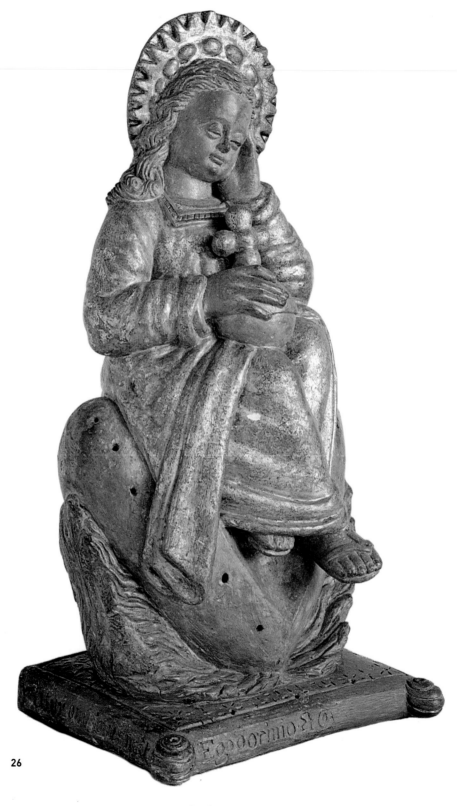

26

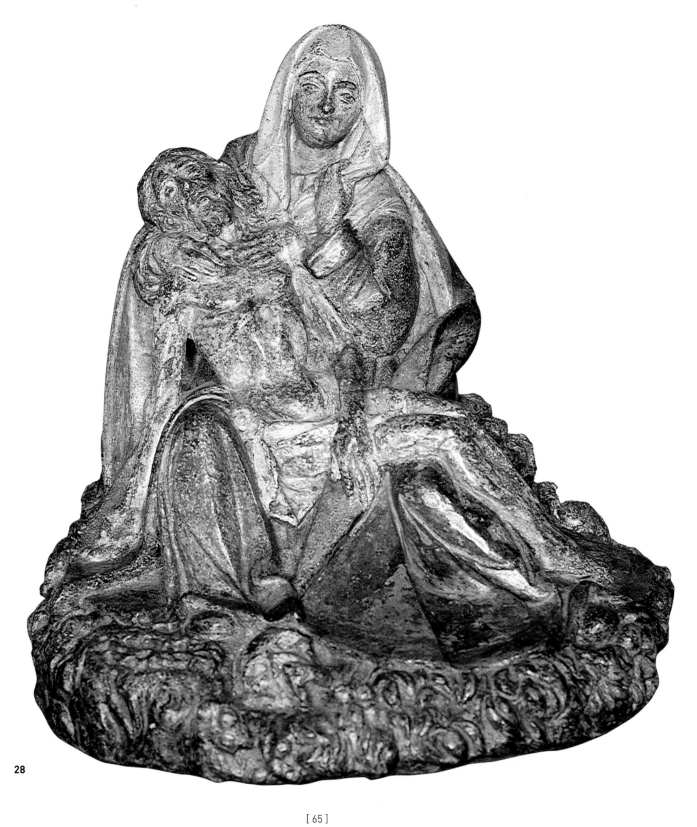

28

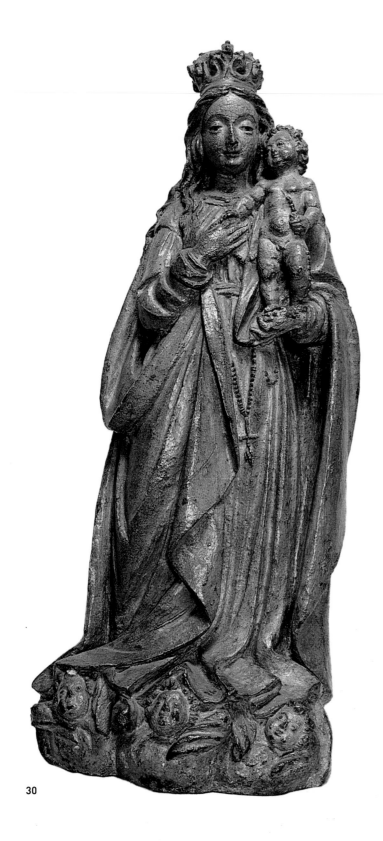

30

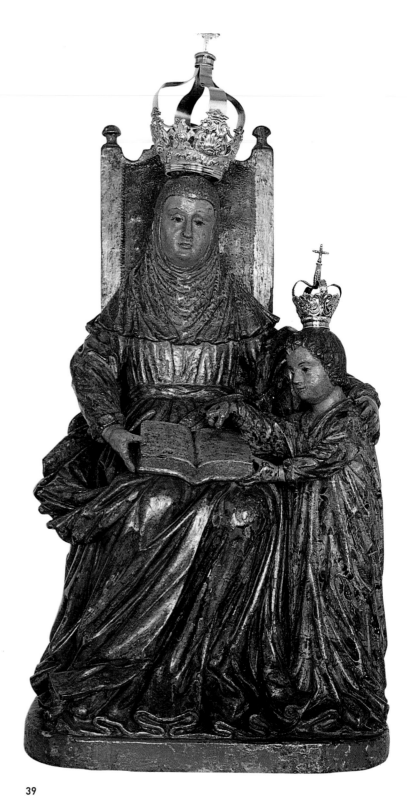

39

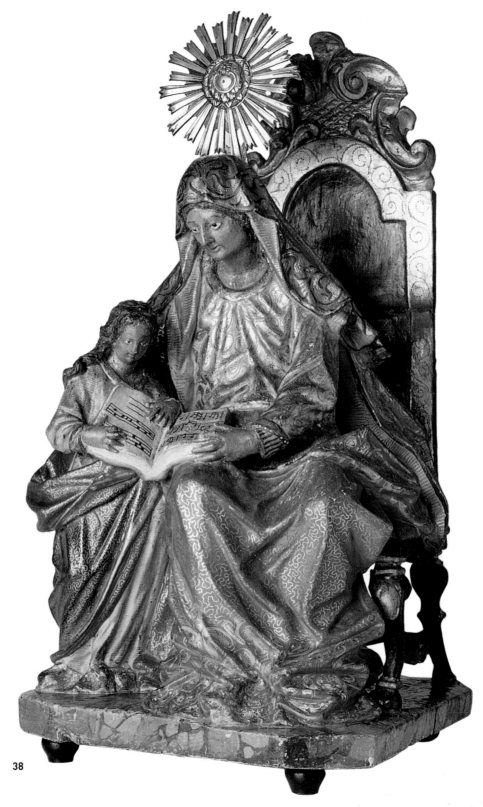

38

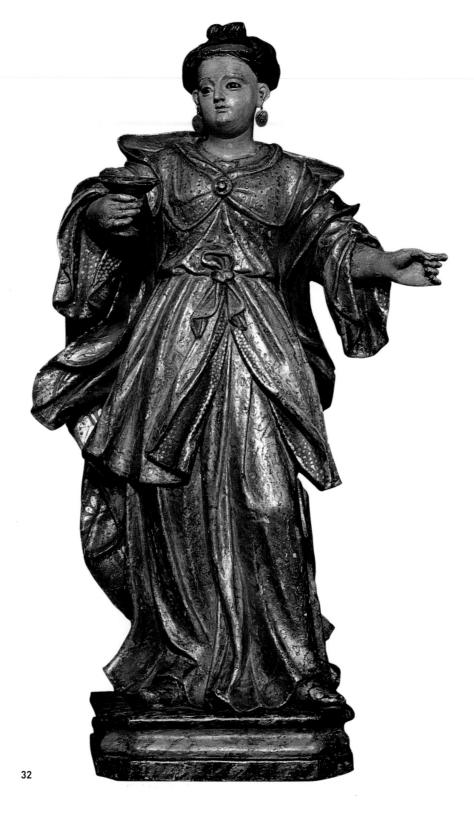

32

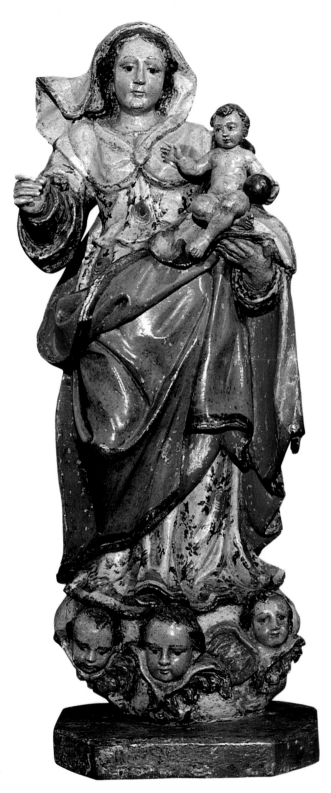

34

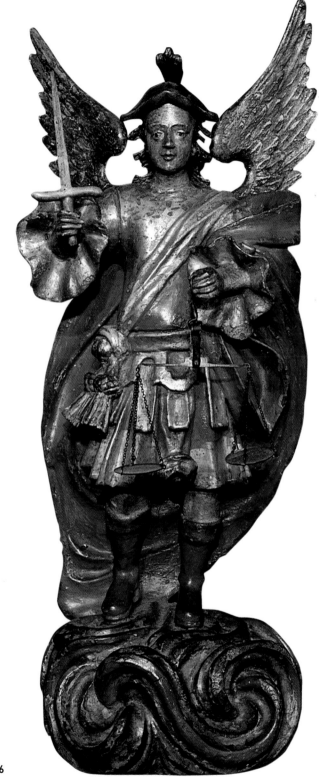

36

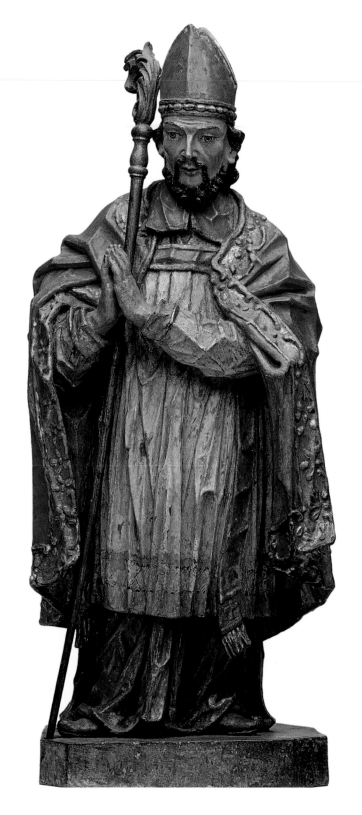

42

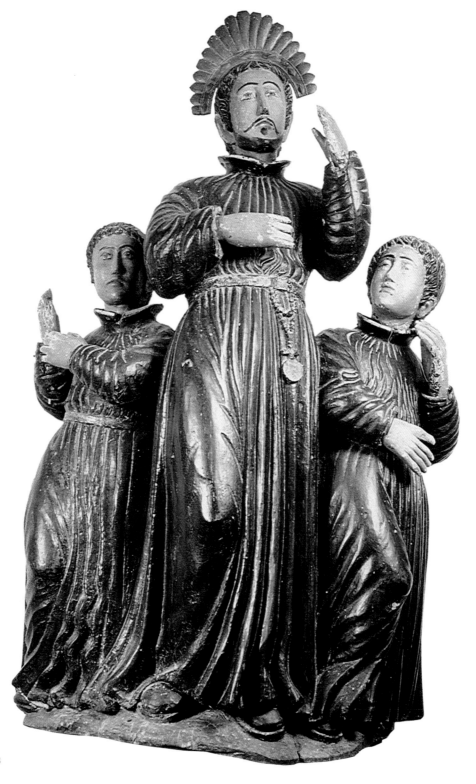

43

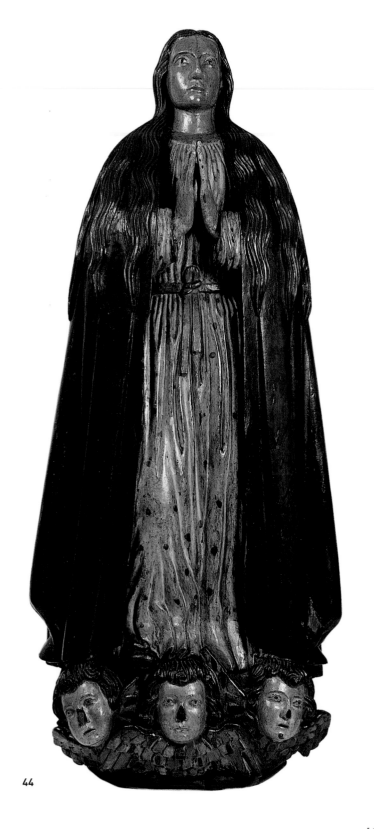

44

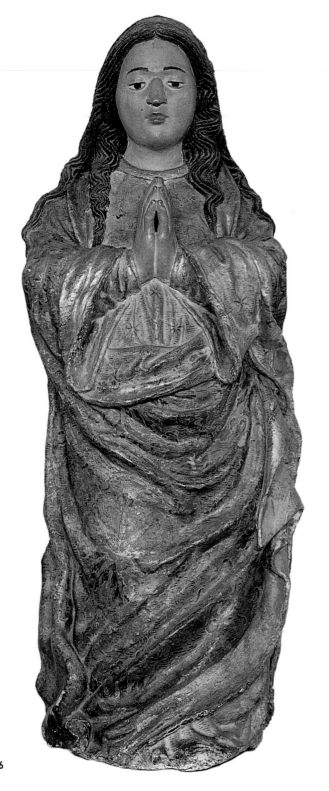

46

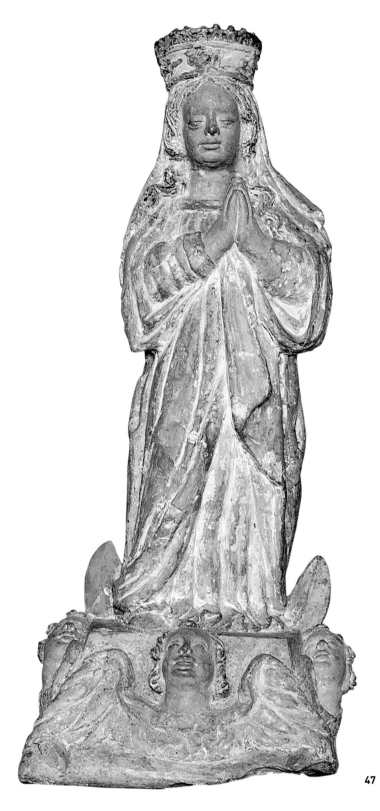

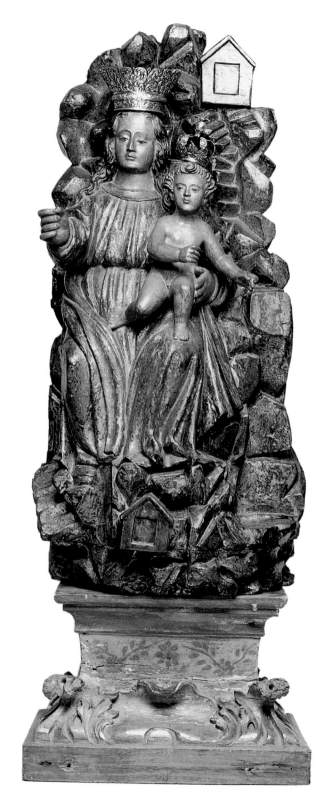

47 51

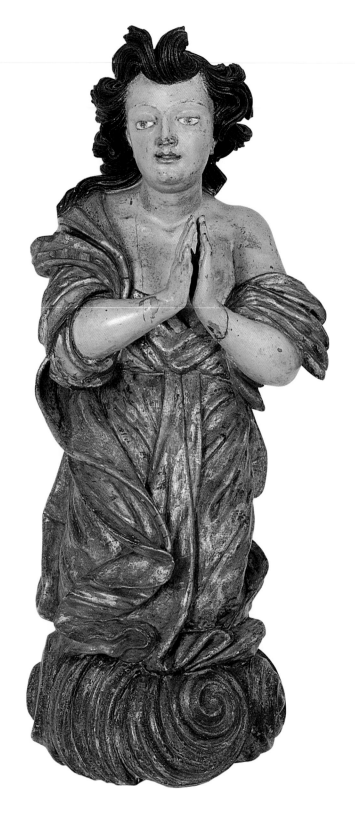

49

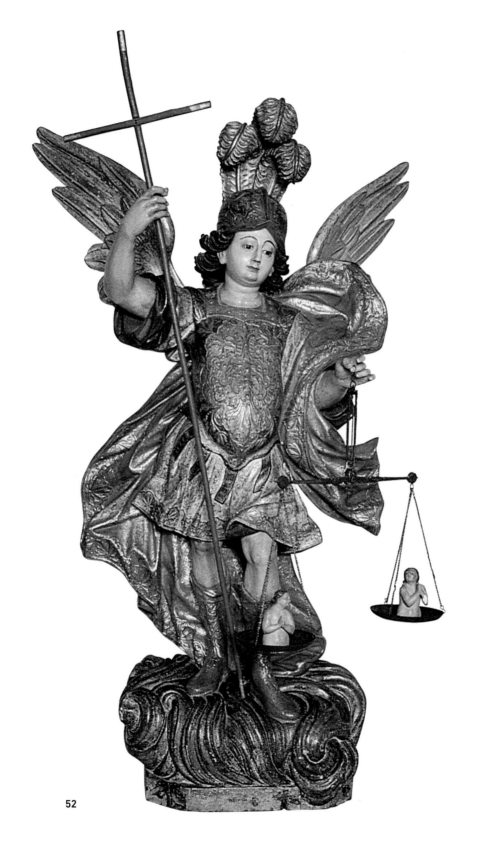

52

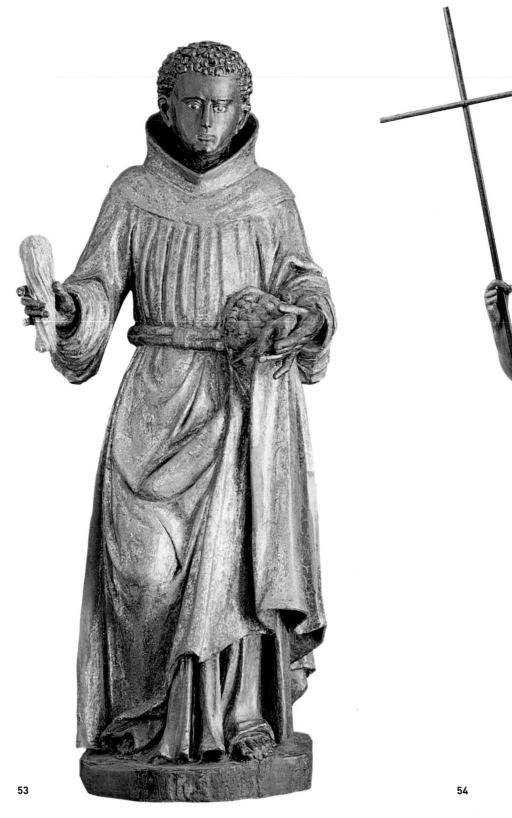

53

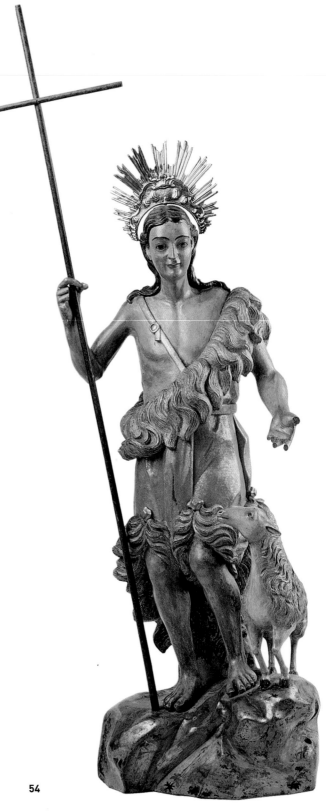

54

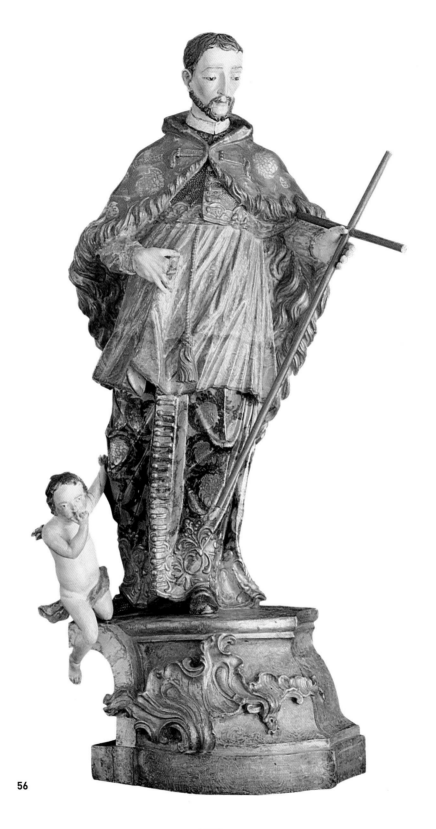

56

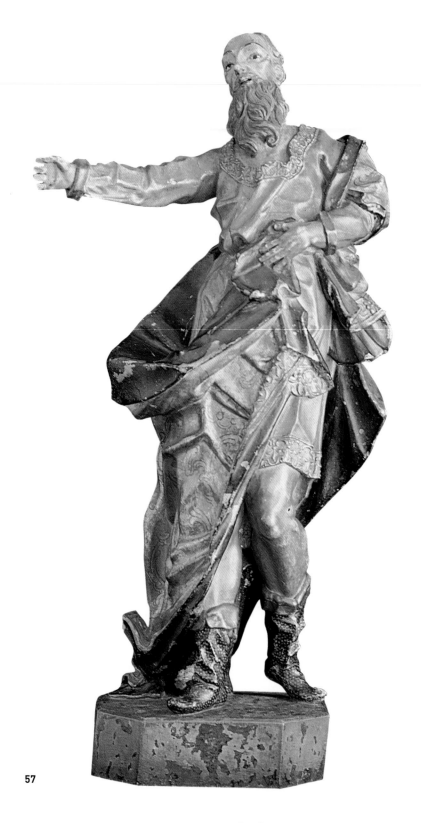

57

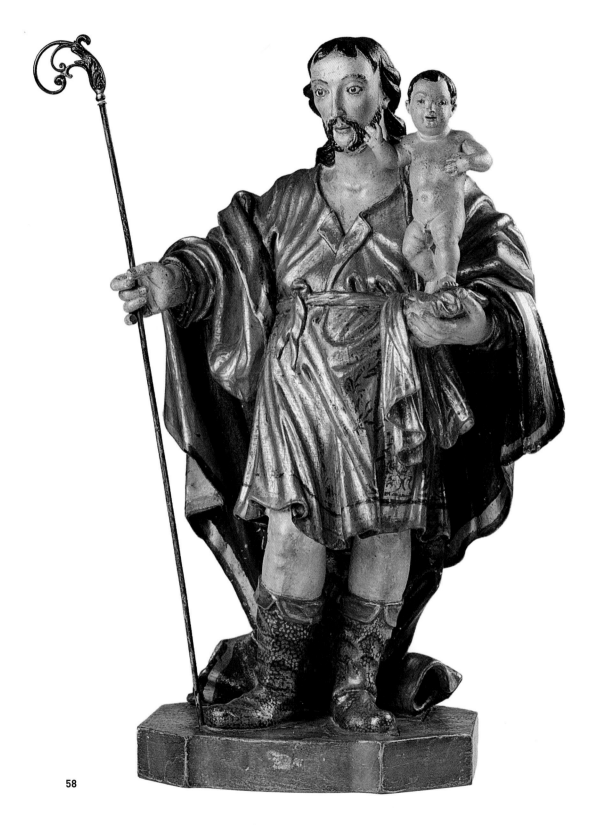

58

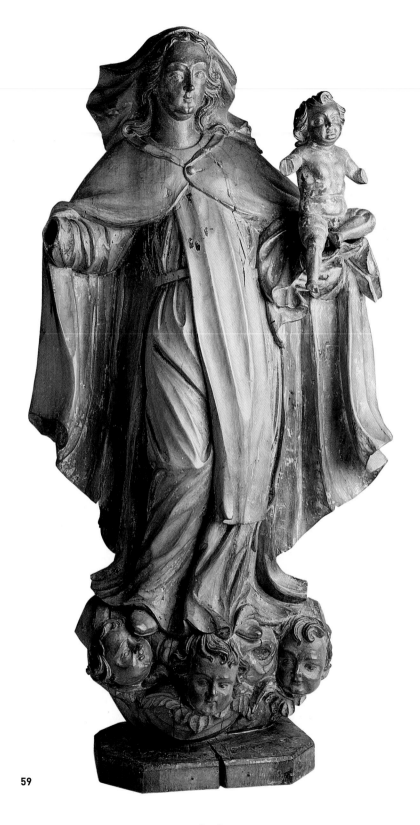

59

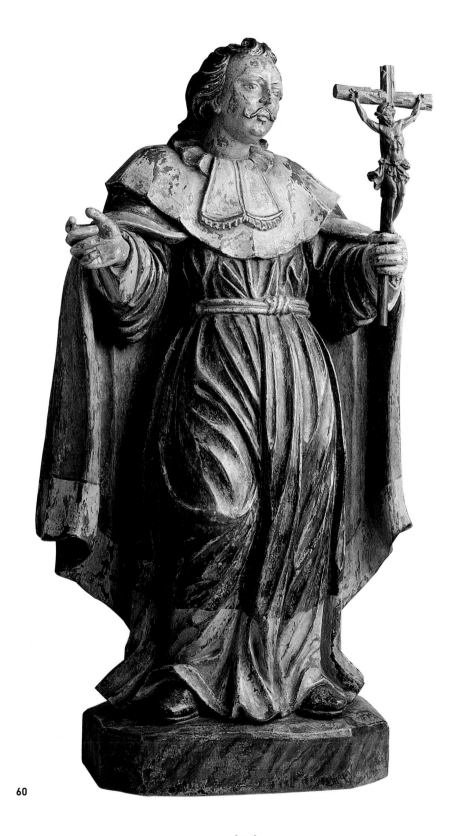

60

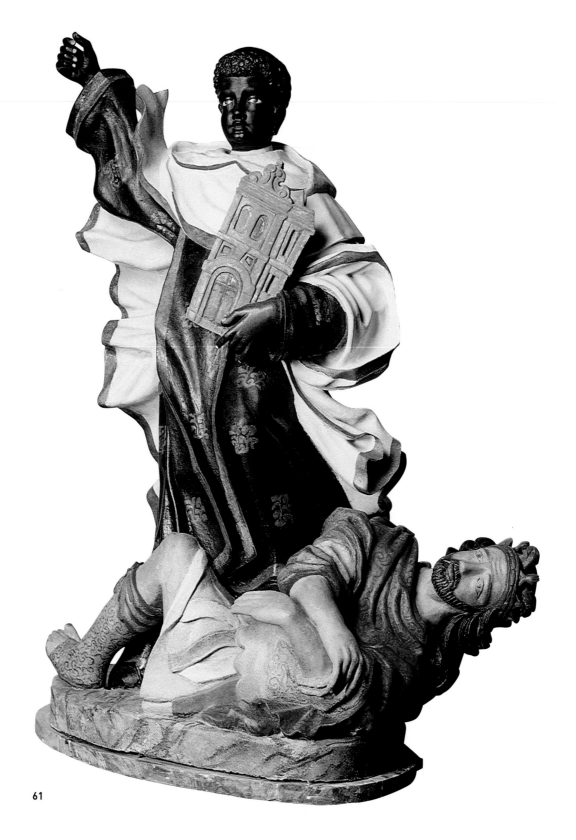

61

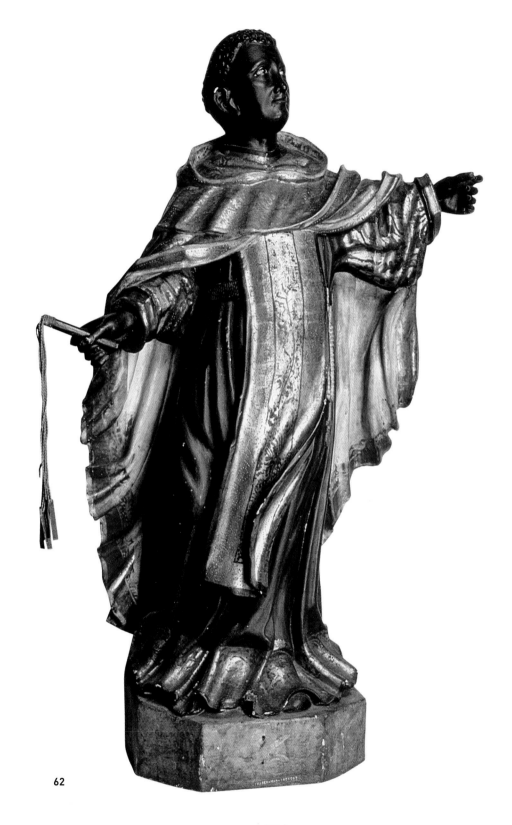

62

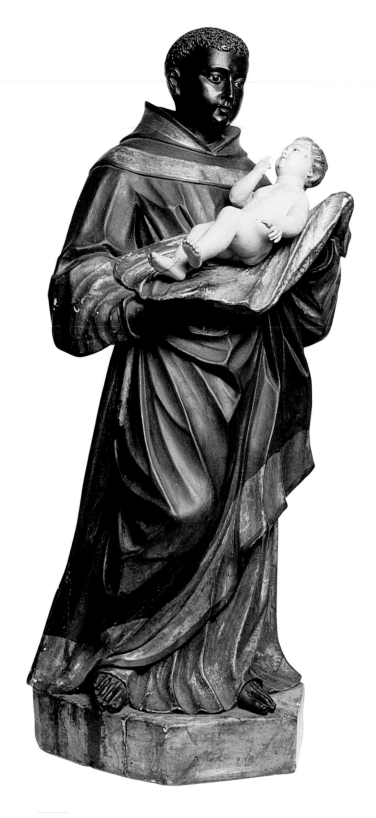

63

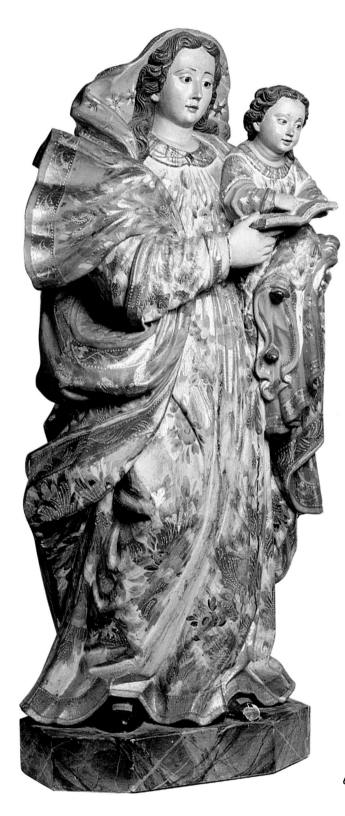

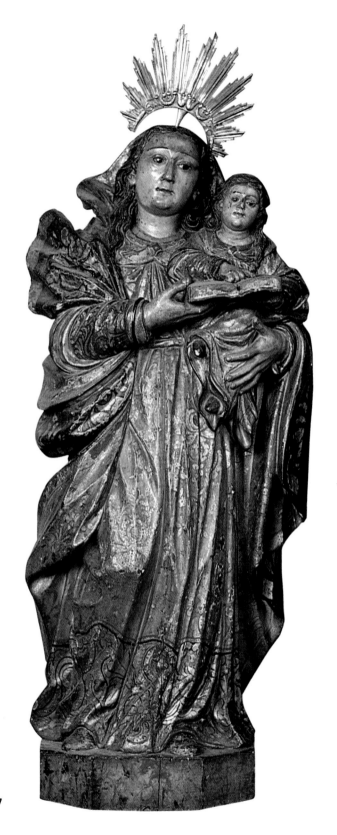

64 67

Checklist of Works of Art in the Exhibition

Cat. nos 1–10 come from the Museu do Oratório, Coleção Angela Gutierrez, Ouro Preto

1
Domestic altarpiece with **Our Lady of The Purification**
Wood (jacaranda) and gilding, the statue with polychrome and gilding
103 × 66 × 30 cms
18th century, Rio de Janeiro
AG 96.109/0

2
Travelling altarpiece with **Our Lady Mother of Mankind**
Wood with polychrome and gilding
80 × 35 (diameter) cms
Minas Gerais, attributed to Francisco Vieira Servas (active from 1753 to the early 19th century)
AG 96.115/0

3
Travelling shrine with **Saint Lazarus**
Wood with polychrome and painted paper
43 × 24 (diameter) cms
18th century, from the north-east
AG 96.126/0

4
Domestic shrine with the **Crucifixion**, the **Virgin Mary, Saint Joseph with the Infant Christ, Saint Sebastian, Saint Anne teaching the Virgin, Saint Joachim,** and, below, the **Nativity with Shepherds and Kings in adoration**
Wood with polychrome, with painted calcite figures
64 × 25 × 13 cms
18th century, Minas Gerais
AG 96.041/0

5
Domestic shrine with **The Nativity**
Wood with polychrome and gilding
25 × 27 cms
Late 18th or early 19th century, Diamantina, Minas Gerais
Intended for a bedroom
AG 96.029/0

6
Domestic altarpiece with **Christ on the Cross**, the **Virgin Mary** and **Saint John the Evangelist** at the foot, and **Our Lady of Mercy** and **Saint Anthony with the Christ Child**
The painted backdrop attributed to Manoel da Costa Ataíde (1762–1830)
Wood with polychrome and gilding, the crucifix with silver additions, and the figures at the foot of the cross in silver
55 × 35 cms
Late 18th century, Minas Gerais
AG 96.034/0

7
Domestic altarpiece with **Christ on the Cross**, painted images of the Virgin Mary and Saint John the Evangelist, and scenes from the Passion of Christ on the doors
Wood with polychrome and gilding, the crucifix with mother-of-pearl and silver
36 × 20 × 7 cms
18th century, Minas Gerais
AG.96.023/0

8
Domestic altarpiece with **Saint Anthony and the Christ Child**, and painted images of the same saint and of Saint Dominic on the doors
Wood with polychrome and gilding
74 × 46 × 27 cms
18th century, Minas Gerais
AG.96.057/0

9
Travelling shrine with (from left to right and top to bottom) **Saint Joachim**, **Saint Joseph**, **Saint Francis**, the **Immaculate Conception**, **Saint Anne teaching the Virgin**, **Saint Barbara**, **Saint Dominic**, **Saint Blaise** and **Saint Anthony**
Wood with polychrome and gilding
45 × 15 (diameter) cms
18th century, from Ceará
AG 96.114/0

10
Travelling shrine with **Saint Anne teaching the Virgin**, the **Immaculate Conception**, and **Saint Joseph of the Boots**
Wood with polychrome and gilding
45 × 27 × 26 (diameter) cms
18th century, Minas Gerais
AG 96.113/0

Silver (cat. 11–25)

11
Baptismal Shell
15 × 13 × 7 cms
18th century, São Paulo
Private Collection

12
Viaticum
20 × 11 × 5 cms
17th century, Villa Bella da Santíssima Trindade, Mato Grosso
Private Collection

13
Ewer
36 × 33 × 19 cms
18th century, Minas Gerais
Private Collection

14
Bowl
8 × 52 × 40 cms
18th century, Minas Gerais
Private Collection

15
Alms tray with the Dove of the Holy Spirit
5 × 28 cms (diameter)
18th century, Minas Gerais
Private Collection

16
The Dove of the Holy Spirit
27 × 18 × 10 cms
18th century, from Araçariguama, São Paulo
Private Collection

17
The Dove of the Holy Spirit
15 × 10 cms (diameter)
18th century, Minas Gerais
Private Collection

18
Confraternity badge, with The Virgin and Child
12 × 8 × 3 cms
18th century, Minas Gerais
Private Collection

19
Purification Bowl with lid and stand
9.5 × 12 cms (diameter)
18th century, Minas Gerais
Private Collection

20
Crown
23 × 16 cms (diameter)
18th century
From a statue of the Virgin and Child
Private Collection

21
Incense-boat in the form of a galleon
18 × 24 × 10 cms
17th century, Bahia
Private Collection

22
Incense-boat in the form of a galleon
9 × 18 × 11 cms
17th century, São Paulo
Private Collection

23
Processional Cross
85 × 58 × 5 cms
18th century
Beatriz and Mário Pimenta Camargo Collection

24
Pair of Candleholders
75 × 25 × 25 cms
18th century, Bahia
Private Collection

25
Pair of Decorative Urns from an Altar Ensemble
82 × 31 × 15 cms
18th century
Private Collection

26
Frei Agostinho da Piedade (documented 1619–d.1661)
Sleeping Infant Christ
Terracotta with some gilding
39 × 22 × 18 cms
Inscribed on the base *Ego dormio et cor meum vigilat: parce mihi domine Frey Agostinho Religiozo de S. Bêto* and on the reverse, *Frei Agostinho / Amor*
(*I sleep, but my heart is awake: have mercy on me, O Lord, Frei Agostinho Priest of St Benedict. Frei Agostinho/ Love*)
Monastery of Sâo Bento, Olinda

27
Attributed to Frei Agostinho de Jesus (d.1661)
Our Lady of the Rosary
Terracotta with polychrome
50 × 23 × 25 cms
From São Paulo
Private Collection

28
Attributed to Frei Agostinho de Jesus
(d.1661)
Pietà
Terracotta with polychrome, inscribed with
the date 1654
34 × 36 × 31 cms
From Santana do Parnaíba, São Paulo
Private Collection

29
Our Lord of the Cold Stone
Terracotta with polychrome
47 × 21 × 24 cms
17th century, São Paulo
Private Collection

30
Our Lady of the Rosary
Terracotta with polychrome
53 × 26 × 23 cms
17th century, São Paulo
Private Collection

31
Saint Barbara
Wood with polychrome
49 × 29 × 16 cms
18th century, Minas Gerais
Mr and Mrs José Maria Carvalho Collection

32
Saint Lucy
Terracotta with polychrome
48 × 28 × 16 cms
18th century, Ouro Preto
Mr and Mrs José Maria Carvalho Collection

33
Attributed to the Master of Oliveira (active
later 18th century)
Pietà
Wood with polychrome
36 × 25 × 17 cms
18th century, Oliveira, Minas Gerais
Mr and Mrs José Maria Carvalho Collection

34
Attributed to the Master of Oliveira (active
later 18th century)
Our Lady of the Rosary
Wood with polychrome
49 × 20 × 16 cms
18th century, Oliveira, Minas Gerais
Mr and Mrs José Maria Carvalho Collection

35
Attributed to the Master of Piranga (active
late 18th century)
Saint Augustine
Wood with polychrome
54 × 27 × 16 cms
Second half of the 18th century, Minas
Gerais
Private Collection

36
Attributed to the Master of Piranga (active
late 18th century)
Saint Michael the Archangel
Wood with polychrome and gilding
42 × 22 × 18 cms
Mr and Mrs José Maria Carvalho Collection

37
Saint Michael the Archangel
Wood with polychrome
66.5 × 32.5 × 20.5 cms
18th century, Minas Gerais
Mr and Mrs José Maria Carvalho Collection

38
Saint Anne teaching the Virgin
Wood with polychrome and gilding
49 × 26 × 26 cms
Second half of the 18th century, Pernambuco
Museu do Estado de Pernambuco
Fundarpe – Secretaria de Cultura, Recife

39
Saint Anne teaching the Virgin
Wood with polychrome and gilding
64 × 36 × 28 cms
18th century, Minas Gerais
Angela Gutierrez Collection

40
Attributed to Antônio Francisco Lisboa,
known as Aleijadinho (1738–1814)
Saint Joseph of the Boots
Wood with polychrome
32 × 11 × 8 cms
Angela Gutierrez Collection

41
Attributed to Antônio Francisco Lisboa,
known as Aleijadinho (1738–1814)
Saint Anthony with the Christ Child
Wood with polychrome
37 × 21 × 14 cms
Mr and Mrs José Maria Carvalho Collection

42
Antônio Francisco Lisboa, known as
Aleijadinho (1738–1814)
Bishop Saint
Wood with polychrome and gilding
46 × 20 × 16 cms
Beatriz and Mário Pimenta Camargo
Collection

43
Saint Francisco Xavier and Companions
Wood with polychrome
96 × 57 × 29 cms
18th century, from the chapel of Camobi,
Santa Maria
Museu Vicente Pallotti, Santa Maria, Rio
Grande do Sul

44
The Virgin of the Immaculate Conception
Wood with polychrome
103 × 49 × 49 cms
18th century, from a Jesuit missionary
settlement
Museu Júlio de Castilhos, Porto Alegre, Rio
Grande do Sul

45
Infant St John the Baptist
Wood with polychrome
75 × 30 × 28 cms
17th or 18th century, from São Martinho,
Santa Maria
Museu Vicente Pallotti, Santa Maria, Rio
Grande do Sul

46
Attributed to Joâo Gonçalo Fernandes,
second half of the 16th century
The Immaculate Conception
Terracotta with polychrome and gilding
111 × 40 × 32 cms
Museu de Arte Sacra de Santos, Santos

47
The Virgin Mary as a Young Girl
Terracotta with polychrome
54 × 24 × 21 cms
Late 16th century, Sâo Paulo
Private Collection

48
Frei Agostinho da Piedade (documented
1619–d.1661)
Saint Barbara
Terracotta with polychrome
66 × 28 × 27 cms
Private Collection

49
Francisco Xavier de Brito (d.1751)
Angel
Wood with polychrome and gilding
92.5 × 34 × 34 cms
One of a pair of angels, c.1740
Nossa Senhora do Pilar, Ouro Preto, Minas
Gerais

50
Our Lady of Mount Carmel
Wood with polychrome and gilding
110 × 54 × 40 cms
18th century
Museu de Arte Sacra da Arquidiocese
de Curitiba

51
Our Lady of Montserrat
Wood, with polychrome and gilding
88 × 39 × 32 cms
First half of the 18th century, Minas Gerais
Beatriz and Mário Pimenta Camargo
Collection

52
Saint Michael the Archangel
Wood, with polychrome and gilding
121 × 78 × 50 cms
18th century
Private Collection

53
Saint Benedict of Palermo
Wood with polychrome and gilding
83 × 46 × 42 cms
18th century, Minas Gerais
Church of Nossa Senhora do Rosario dos
Pretos, Mariana

54
Saint John the Baptist
Wood, with polychrome and gilding
90 × 38 × 32 cms
18th century, Minas Gerais
Beatriz and Mário Pimenta Camargo
Collection

55
Saint Joseph of the Boots
Wood with polychrome
64.8 × 31.7 × 19 cms
18th century, Minas Gerais
Private Collection

56
Antônio Francisco Lisboa, known as
Aleijadinho (1738–1814)
Saint John Nepomuk
Wood, with polychrome and gilding
88 × 39 × 26.5 cms
Museu Arquidiocesano de Arte Sacra,
Mariana

57
Antônio Francisco Lisboa, known as
Aleijadinho (1738–1814)
Saint Joachim
Wood with polychrome and gilding
78 × 40 × 20 cms
Museu Arquidiocesano de Arte Sacra,
Mariana

58
Antônio Francisco Lisboa, known as
Aleijadinho (1738–1814)
Saint Joseph of the Boots
Wood with polychrome and gilding
57.5 × 43 × 42 cms
Collection of the Governo do Estado, Sâo
Paulo

59
Antônio Francisco Lisboa, known as
Aleijadinho (1738–1814)
Our Lady of Mount Carmel
Wood
82 × 43 × 21 cms
Private Collection

60
Antônio Francisco Lisboa, known as
Aleijadinho (1738–1814)
Saint Louis of France
Wood with polychrome and gilding
73 × 40 × 24 cms
1750, Ouro Preto, Minas Gerais
Private Collection

61
Saint Elesbaan Victorious
Wood with polychrome and gilding
146 × 113 × 61 cms
18th century, from the black brotherhood of
Our Lady of the Rosary, Olinda
Confraria de Nossa Senhora do Rosário dos
Homens Pretos, Olinda

62
Saint Moses the Hermit
Wood with polychrome and gilding
137 × 65 × 56 cms
18th century, Pernambuco
5° Superintendência Regional do IPHAN –
Recife

63
Saint Anthony of Caltagirona
Wood with polychrome and gilding
112 × 56 × 36 cms
18th century, Pernambuco
5° Superintendência Regional do IPHAN –
Recife

64
Saint Anne teaching the Virgin
Wood with polychrome and gilding
105 × 48 × 31 cms
18th century, Pernambuco
5° Superintendência Regional do IPHAN –
Recife

65
Saint Cosmas
Wood with polychrome and gilding
85.5 × 43 × 31 cms
18th century, Pernambuco
5° Superintendência Regional do IPHAN –
Recife

66
Saint Damian
Wood with polychrome and gilding
85.5 × 40 × 32 cms
18th century, Pernambuco
5° Superintendência Regional do IPHAN –
Recife

67
Saint Anne teaching the Virgin
Wood with polychrome and gilding
97 × 43 × 26 cms
18th century, Pernambuco
Fundação Pierre Chalita, Maceló

68
Attributed to the Master of Angra
Saint Francis of Assisi
Terracotta with polychrome
62 × 21 × 22 cms
17th century
Private collection

Named Sculptors Represented in the Exhibition

Joâo Gonçalo Fernandes (active 1560s)

A Portuguese-born artist active in the São Paulo region in the mid-sixteenth century, his terracotta sculptures have been said to be the first statues made in Brazil, as distinct from the many imported from Lisbon in this period. (cat. 46)

Frei Agostinho da Piedade (documented 1619–d.1661)

Born probably c.1580, in Portugal, Frei Agostinho took his vows as a Benedictine monk in 1619 in Salvador. His terracotta sculptures are documented from 1636–42 (i.e. those that he signed and dated). He apparently set his art aside to become the administrator of the Benedictine estate at Itapoã and to serve as chaplain at the church of Graça in Salvador. (cat. 26, 48)

Frei Agostinho de Jesus (d.1661)

Born in Rio de Janeiro, probably c.1610, Frei Agostinho is documented at the Benedictine monastery in Bahia before and after taking his vows in Portugal around 1630. A pupil of Frei Agostinho da Piedade, he later lived at the monastery of São Bento at São Paulo, and in other Benedictine houses in Santos and Parnaíba. Like his master, he worked entirely in terracotta. (cat. 27, 28)

Francisco Xavier de Brito (d.1751)

Born in Lisbon, De Brito was documented in Rio de Janeiro in 1735 as a master sculptor. He worked extensively in Minas Gerais, where his monumental sculpture was particularly influential. De Brito's sculpture and carving is in wood. (cat. 49)

Antônio Francisco Lisboa, known as Aleijadinho (1738–1814)

Although early sources give as his date of birth 1730, Aleijadinho was baptised in 1738 and scholars today generally accept this as his date of birth. The illegitimate son of the Portuguese-born architect Manoel Francisco Lisboa and an African slave, Aleijadinho was a highly original architect and sculptor (in wood and in stone) who worked exclusively in Minas Gerais. His nickname (meaning 'Little Cripple') derives from the fact that he suffered from a wasting disease from 1777, with a progressive deformation of his limbs. (cat. 40–42, 56–60)

Some Popular Brazilian Cults of Saints Represented in the Exhibition

The Virgin Mary

The cult of the Virgin Mary was extremely important in Brazil, thanks to the Jesuit, Francisan, Benedictine and Carmelite orders in particular. The kingdom of Portugal had been dedicated to the Madonna since the twelfth century, and the missionaries who came to Brazil from the early sixteenth century onwards brought with them a strong devotional tradition. The Virgin was venerated under a variety of aspects which referred to theological ideas (such as the Immaculate Conception, embodying concepts of purity and predestination), to particular qualities (such as beauty, virginity, or intercessionary powers), to episodes from the life of the Virgin (such as Our Lady of Sorrows, at the foot of the Cross) or to specific places or occasions when visions or miracles occurred (such as Our Lady of Mount Carmel).

The cult of the Immaculate Conception was the most important of these, and was promoted in particular by the Franciscans, while the dedication of Portugal and its empire to the Immaculate Conception by João IV in 1646 gave the cult additional vigour and significance. Between 1503 and 1822, a total of 502 parishes were established in Brazil, with almost 300 of these dedicated to the Virgin Mary under different invocations, including 94 dedicated to the Immaculate

Conception. The importance of the Madonna in popular devotion is also reflected in artistic production, where a high proportion of images in painting and sculpture are of the Virgin Mary. Our Lady of the Rosary (whose invocation refers to the vision in which the Virgin presented the rosary to St Dominic) was widely venerated, in particular by slaves and members of black brotherhoods.

Saint Anne

The mother of the Virgin Mary, St Anne was a very popular saint in Brazil. Since she had carried Mary, a precious treasure, in her womb, St Anne was the patron saint of miners. A large number of sculpted images of the saint can be found in Minas Gerais, where gold was discovered in the mid-1690s, and indeed the purity and rarity of gold was associated with the qualities of the Virgin Mary. The subject of St Anne teaching the young Mary enjoyed special favour in Brazil: the mother is shown either standing holding the little girl, who carries an open book, in her arms, or else seated in an often elaborately decorated chair, with Mary at her knees following her lesson in a book held by St Anne. The popularity of this kind of sculpture may reflect the fact that the education (however limited) of women took place exclusively within the family in Brazil in this period.

Saint Joachim

The husband of St Anne, Joachim appears in the earliest apocryphal narratives of the life of the Virgin, and the widely-known *Golden Legend* of 1264 by Jacobus de Voraigne provided much colourful detail on his life, to be further embroidered subsequently. Images of the saint in Brazil are often associated with the extended Holy Family, a popular subject in art there.

Saint Joseph

The cult of St Joseph was strongly promoted by the Counter-Reformation church, with the saint venerated as a protective father and a model of familial virtue. The idea of Joseph's happy or good death, in the presence of his foster-son, Jesus, was a particularly appealing one. As well as being the patron saint of carpenters, Joseph was invoked as a saint who could help ensure a peaceful death, with dignity and in the bosom of the Church. In sculptural images he sometimes appears carrying the infant Christ, or as part of the Holy Family. Statues of *São João de Botas* – St Joseph of the Boots – are common in Brazil, and may refer to the Flight into Egypt. Certainly the idea of a protective saint who had made a long journey into unknown desert terrain had great appeal to the miners, ranchers, farmers, hunters and explorers who moved into the harsh and

difficult territories of Brazil's vast interior.

Saint Anthony

Usually venerated in Europe as St Anthony of Padua, after the place where he died, Anthony (1195–1231) had been born in Lisbon and therefore ranked high in the Portuguese pantheon of saints. A Franciscan monk, he is shown in art with a lily and a book, references to his chastity and erudition, or with the Christ Child in his arms. In Brazilian sculpture he is almost invariably shown with the Child. Usually invoked to help find lost objects, the saint was also popular with young women seeking husbands.

Saint Anthony of Noto, or of Caltagirona or Categerena

Born in Africa, the saint was taken prisoner and sold as a slave to Giovanni Landavula in Sicily, where he was baptised and took the name of Anthony. He was a shepherd, renowned for his virtue and his charitable works. He became a Franciscan friar, and on his death in Noto in 1549 was buried in the church of Santa Maria de Gesù. His body was found to be uncorrupt, a sign of sainthood, when his tomb was opened in 1599. St Benedict of Palermo, a Sicilian-born saint whose Ethiopian parents were slaves, was another black saint whose cult had a strong following. These figures from the Counter-Reformation age were particularly venerated by African slaves in Brazil, and both of them may be shown in art holding the Christ Child, as an indication of their special holiness.

Saint Barbara

According to legend, the early Christian St Barbara was shut in a tower by her father, who then killed her because of her faith. He in turn was struck dead by lightning. Usually depicted in art holding a tower and a martyr's palm, St Barbara is the patron of firework-makers, artillerymen, architects and stonemasons, amongst other trades, and is invoked as a protector against fires, lightning and sudden death. In Brazil, her cult was especially popular with African slaves and people of African descent, perhaps because her qualities recalled those of the deity Yansan who had no fear of death, and who was associated with lightning.

Saint Elesbaan

A Christian king of Ethiopia at the time of the emperor Justinian, Elesbaan (Kaleb) ruled over the Axoum people. His great adversary, whom he successfully defeated, was Dhu-newas, king of the Hamerites and a persecutor of Christianity. Later, Elesbaan renounced his crown and distributed his goods to the poor before becoming a monk; having led an exemplary monastic life he died around 555. He decreed that his royal crown should hang at the tomb of Christ in Jerusalem. The fact that Dhu-newas was Arabian allows him to be represented as a white king, trampled under the feet of the victorious Elesbaan who is shown robed as a monk.

Saint Moses the Hermit

An early Christian saint and martyr, Moses had been a slave in Ethiopia and was known as a strong and mighty man. In his search for knowledge of God, he was converted to Christianity by the monks living in the desert of Scete. He lived an ascetic life in the desert, eventually becoming a priest and abbot.

Saint Francis Xavier

The greatest Jesuit saint after St Ignatius Loyola, Francis Xavier (1506–52) worked in India, Malaya, Japan and elsewhere in the Far East, dying at Sancian as he was about to enter China. His body was buried in Portuguese Goa. As a famous and exemplary missionary, his cult was energetically promoted by the Jesuits in Brazil. He was named as the patron of Salvador, the first capital city of Brazil, after the lifting of a plague in 1686.

Saint John Nepomuk

A native of Nepomuk, in Bohemia, John (c.1340–93) was renowned for his holiness. He was thrown into the river Moldau at Prague and drowned by order of the king, Wenceslaus IV: according to tradition this was because he refused to disclose the secrets of the confessional. He is venerated as a protector of bridges and is invoked against floods. His cult was given renewed strength in the eighteenth century when he was honoured for his protection of the sacrament of confession. St John is depicted in art robed as a canon, contemplating a crucifix; occasionally he has a finger to his lips or carries the inscription *Tacui*.

Saint Lucy

One of the most famous of the early Christian saints, Lucy was martyred in Syracuse, Sicily, at the time of the emperor Diocletian. Tradition held that in order to dissuade suitors, she put out her eyes to spoil her beauty. However the association of Lucy with sight may derive from the fact that her name means 'light'. She is shown in art with her eyes on a platter, and a martyr's palm; sometimes she also carries a sword, the instrument of her martyrdom.

Saint Michael the Archangel

Described in the Bible as leader of the heavenly armies against Lucifer, St Michael is depicted in art as a warrior, clad in armour and bearing a sword, sometimes with the devil in the form of a serpent beneath his feet. He also carries a pair of scales, used for weighing the souls of the dead in order to determine their destiny – Heaven, Hell or temporary punishment in Purgatory. In Portugal, the cult of St Michael and the Souls was especially popular, with the faithful praying for the release of the souls of the dead from Purgatory and a variety of roadside shrines or small chapels were dedicated to those Holy Souls destined for heaven. St Michael and the Souls took root as a cult in Brazil and numerous confraternities were dedicated to this powerful figure.

Saint Sebastian

According to early sources Sebastian was an officer and a favourite of the emperor Diocletian. However as a Christian he was ordered to be killed by being shot with arrows while tied to a tree; he survived, but was subsequently beaten to death. He is depicted in art as a young man, virtually nude, with his body pierced by arrows. The city of Rio de Janeiro was under the patronage of St Sebastian, and the Jesuits brought a relic of the saint there in the late sixteenth century.

Further Reading: Some Sources in English

Appleby, D. P., *The Music of Brazil* (Austin, Texas, 1983)

Alden, D., *Royal Government in Colonial Brazil* (Berkeley and Los Angeles, 1984)

Bethell, L. (ed.), *The Cambridge History of Latin America*, II (Cambridge, 1984)

Bottineau, Y., *Iberian-American Baroque*, transl. K. M. Leake (New York, 1970)

Boxer, C. R., *The Dutch in Brazil, 1624–1654* (Oxford, 1957)

—, *The Golden Age of Brazil, 1695–1750* (Berkeley and Los Angeles, 1969)

Brandão, A. F., *Dialogues of the Great Things of Brazil*, (c.1618) transl. and ed. by F. H. Hall, W. F. Harrison, D. W. Welker (Albuquerque, 1987)

Bury, J. B., '"Estilo" Aleijadinho and the Churches of Eighteenth-Century Brazil', *Architectural Review* CXI (1952), pp.93–100

—, 'The "Borrominesque" Churches of Colonial Brazil', *The Art Bulletin* XXXVII/1 (1955), pp.26–53

—, 'The Architecture and Art of Colonial Brazil', in Bethell (ed.), pp.747–69

Chamberlain, H., *Views and Costumes of the City and Neighbourhood of Rio de Janeiro, Brazil, from Drawings taken by Lieutenant Chamberlain, Royal Artillery, During the Years 1819 and 1820, with Descriptive Explanations* (London, 1822)

Conrad, R. E., *Children of God's Fire. A Documentary History of Black Slavery in Brazil* (Princeton, 1983)

Graham, M., *Journal of a Voyage to Brazil and Residence There During Part of the Years 1821, 1822, 1823* (London, 1824)

Hemming, J., *Red Gold. The Conquest of the Brazilian Indians, 1500–1760* (2nd rev. edn., Cambridge, 1995)

Kindersley, Mrs. N., *Letters from the island of Teneriffe, Brazil, the Cape of Good Hope, and the East Indies* (London, 1777)

Koster, H., *Travels in Brazil* (London, 1816)

Kubler, G., *Portuguese Plain Architecture Between Spices and Diamonds (1521–1706)* (Middletown, 1972)

Kubler, G., and Soria, M., *Art and Architecture in Spain and Portugal and their American Dominions 1500–1800* (Baltimore, 1959)

Léry, J. de, *History of a Voyage to the Land of Brazil* (1587), transl. by J. Whatley (Berkeley and Los Angeles, 1990)

Levine, R. M. and Crocitti, J. J., *The Brazil Reader. History, Culture, Politics* (Durham, North Carolina, 1999)

Levinson, J. A. (ed.), *The Age of the Baroque in Portugal* (New Haven and London, 1993)

Livermore, H. V., and Entwistle, W. J., *Portugal and Brazil* (London, 1953)

Luccock, J., *Notes on Rio de Janeiro and the Southern Parts of Brazil* (London, 1820)

Mann, G., *The Twelve Prophets of Aleijadinho*, with photographs by H. Mann (Austin, Texas 1967)

Mattoso, K. M. de Queirós, *To Be a Slave in Brazil, 1550–1888*, transl. by A. Goldhammer (New Brunswick, 1986)

Mawe, J., *Travels in the Interior of Brazil particularly in the Gold and Diamond Districts* (London, 1812)

Moraes, R. Borba de, *Rare Books about Brazil published from 1504 to 1900 and works by Brazilian authors of the Colonial period* (rev. edn. Los Angeles, 1983)

Ribeiro, M. A. da Oliveira, 'The Religious Image in Brazil', in *Arte Barroco, Mostra do Redescobrimento* (São Paulo, 2000), pp.36–79.

Russell-Wood, A. J. R., *Fidalgos and Philanthropists. The Santa Casa da Misericordia of Bahia, 1550–1755* (London, 1968)

—, 'Female and family in the economy and society of colonial Brazil', in A. Lavrin (ed.), *Latin American Women. Historical Perspectives* (London, 1978), pp.60–100

—, *The Black Man in Slavery and Freedom in Colonial Brazil* (London, 1982)

—, *The Portuguese Empire, 1415–1808. A World on the Move* (Baltimore and London, 1992)

Schwartz, S.B (ed.), *A Governor and His Image in Baroque Brazil. The Funereal Eulogy of Afonso Furtado de Castro do*

Rio de Mendonça by J. Lopes Sierra, transl. by R. E. Jones
 (Minneapolis, 1979)

Schwartz, S.B., *Sugar Plantations in the Formation of Brazilian
 Society. Bahia, 1550–1835* (Cambridge, 1985)

—, 'The Formation of a Colonial Identity in Brazil', in N. Canny
 and A. Pagden (eds), *Colonial Identity in the Atlantic World*
 (Princeton, 1987)

Smith, R. C., 'The Arts in Brazil: (i) Baroque Architecture' in
 Livermore and Entwistle (eds)

—, 'Nossa Senhora da Conceição da Praia and the Joanine
 style in Brazil', *Journal of the Society of Architectural
 Historians* 15:3 (1956), pp.16–23

—, *The Art of Portugal 1500–1800* (London, 1968)

Sousa-Leão, J. de, 'Decorative Art: The Azulejo', in Livermore
 and Entwistle (eds), pp.385–94

Tribe, T. Costa, 'The Mulatto as Artist and Image in Colonial
 Brazil', *The Oxford Art Journal* 19:1 (1996), pp.67–79